LIFE OF THE *Wild*

A WHIMSICAL ADULT COLORING BOOK

BY: KAREN SUE CHEN

Share your work! #KarenSueStudios on social media.

Copyright © 2016 by Karen Sue Chen
All rights reserved. This book or any portion thereof
may not be reproduced or used in any manner whatsoever
without the express written permission of the publisher
except for the use of brief quotations in a book review.

Printed in the United States of America

First Printing, 2016

ISBN 978-1539339267

www.Sunshine-Creative.com

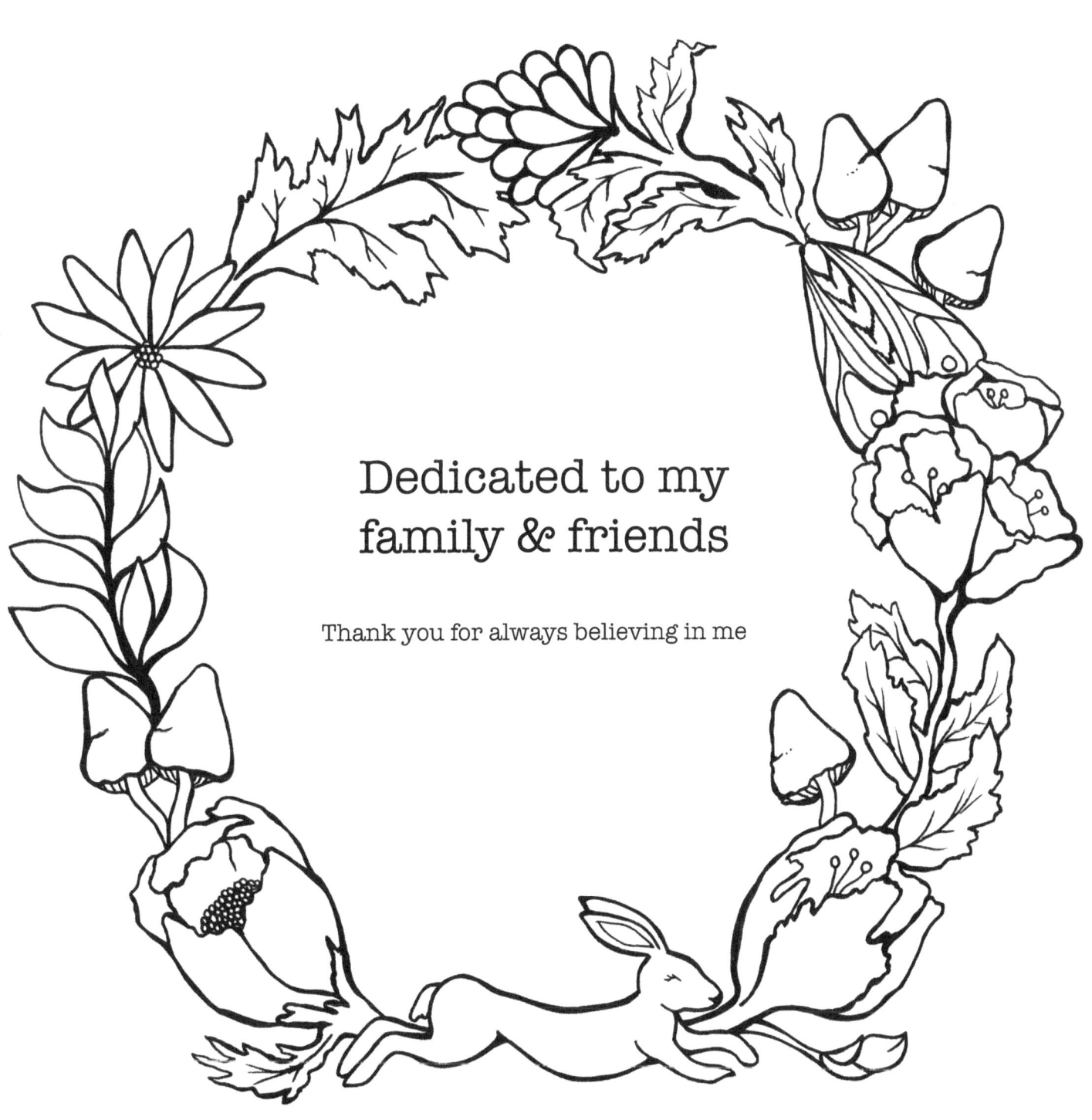

Dedicated to my family & friends

Thank you for always believing in me

A Note From The Author:

Thank you so much for purchasing Life of the Wild! Your support allows me to pursue my dream of being a professional artist. I was born and raised in Texas, and I currently live in California. In my free time I enjoy gardening, yoga, acrobatics, crafting, roller skating, and hanging out with my pet rabbit and dog.

If you enjoyed this book, check out my other coloring books Bloom, Flora and Fauna, Mandala Daydream, Mandalas for Peace, Mandala Secret Garden, and Magic Ocean at Sunshine-Creative.com.

It truly brings me joy to see your finished masterpieces! Please tag @KarenSueStudios or use #KarenSueStudios. And always remember to let sunshine into your life!

Love,

Karen Sue Chen

YouTube @KarenSueStudios

Share your work! #KarenSueStudios on social media.

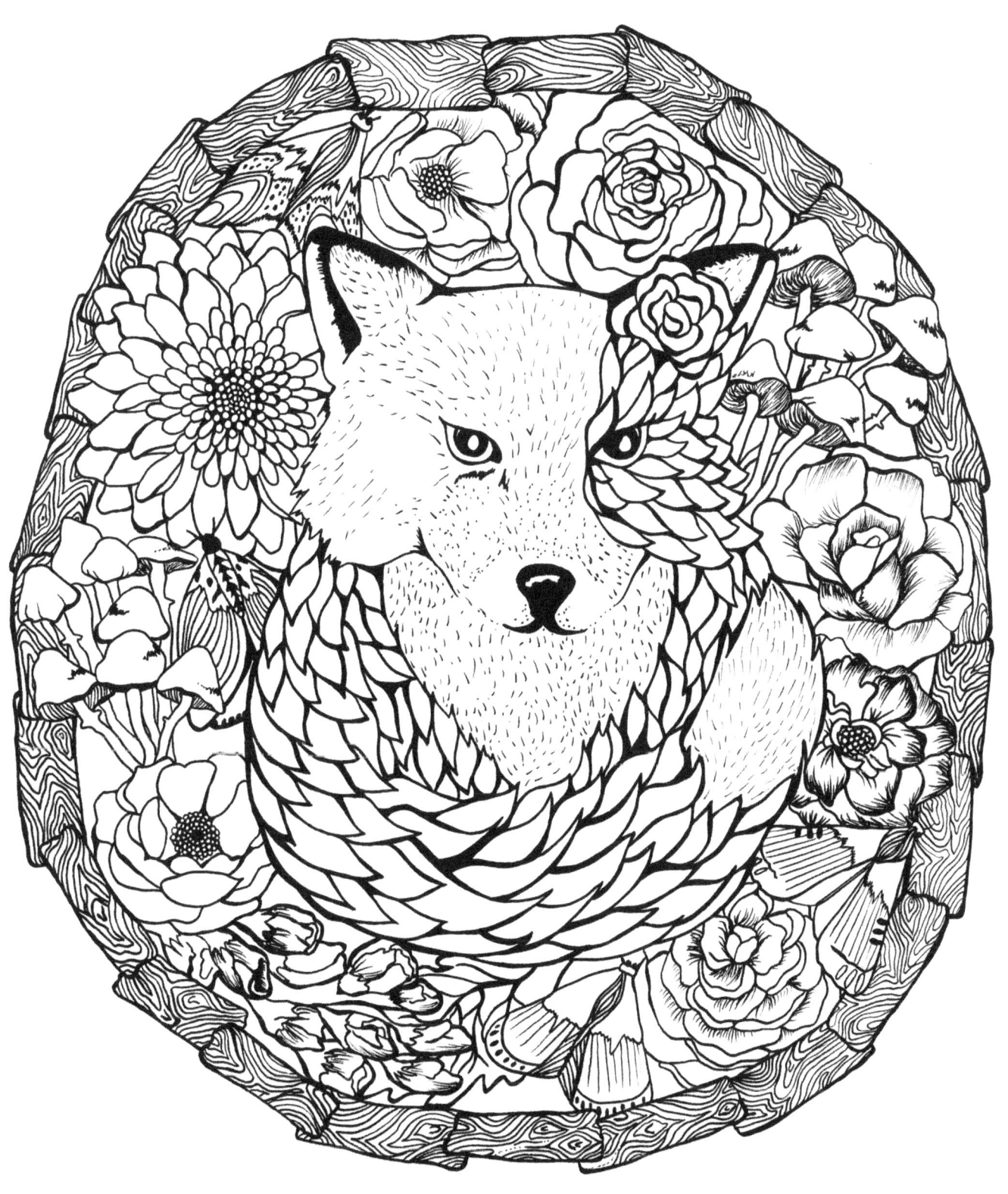

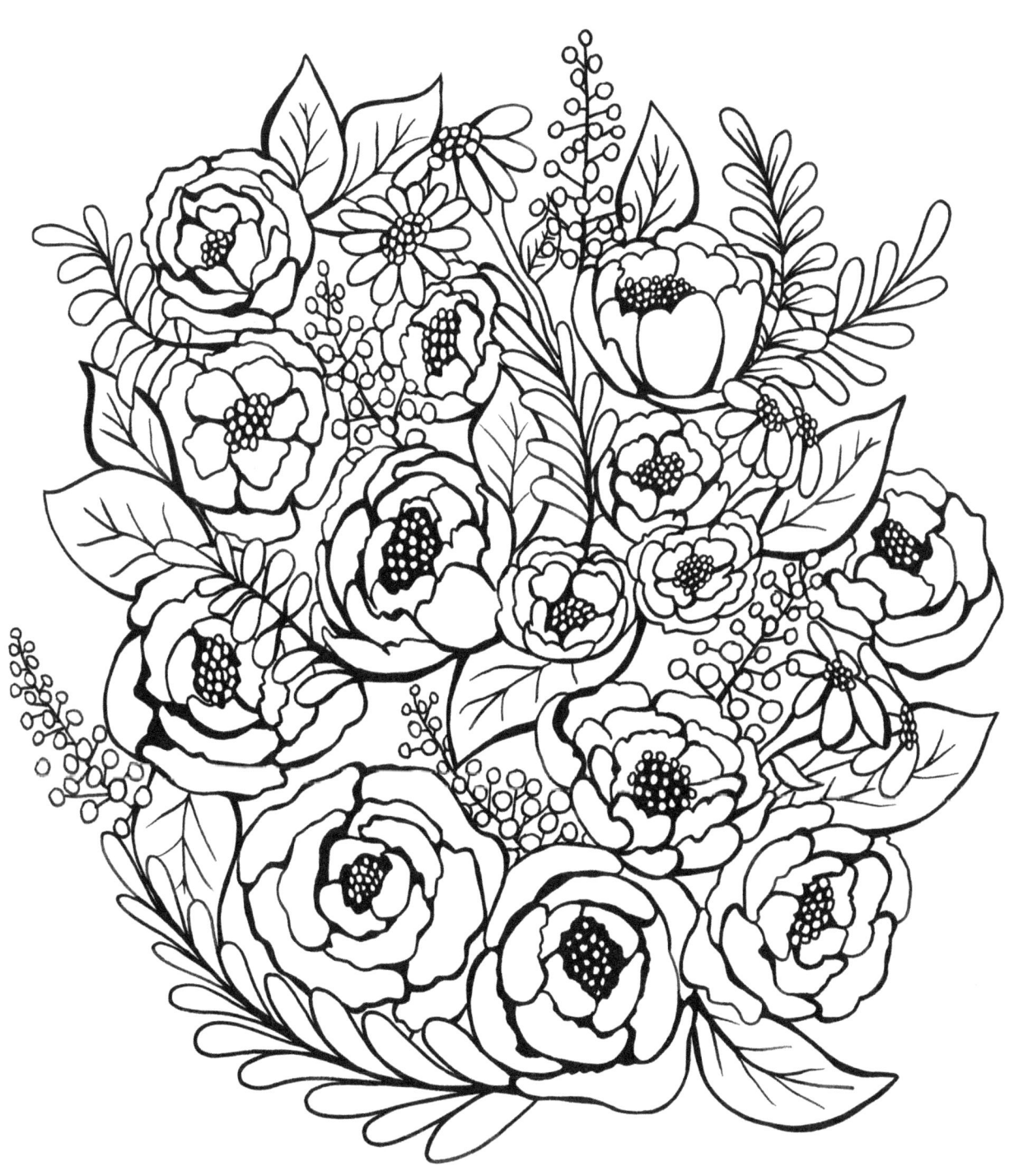

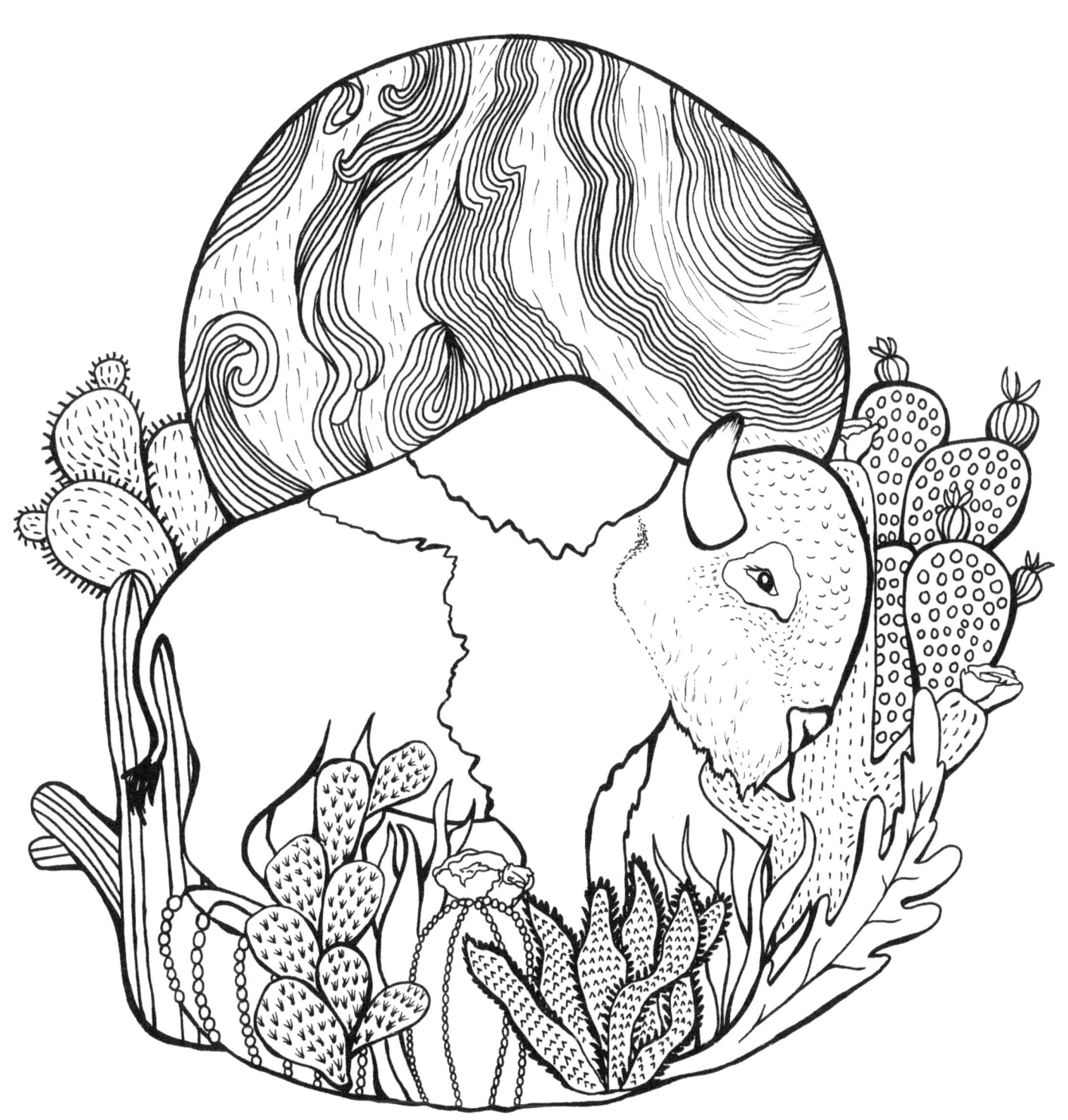

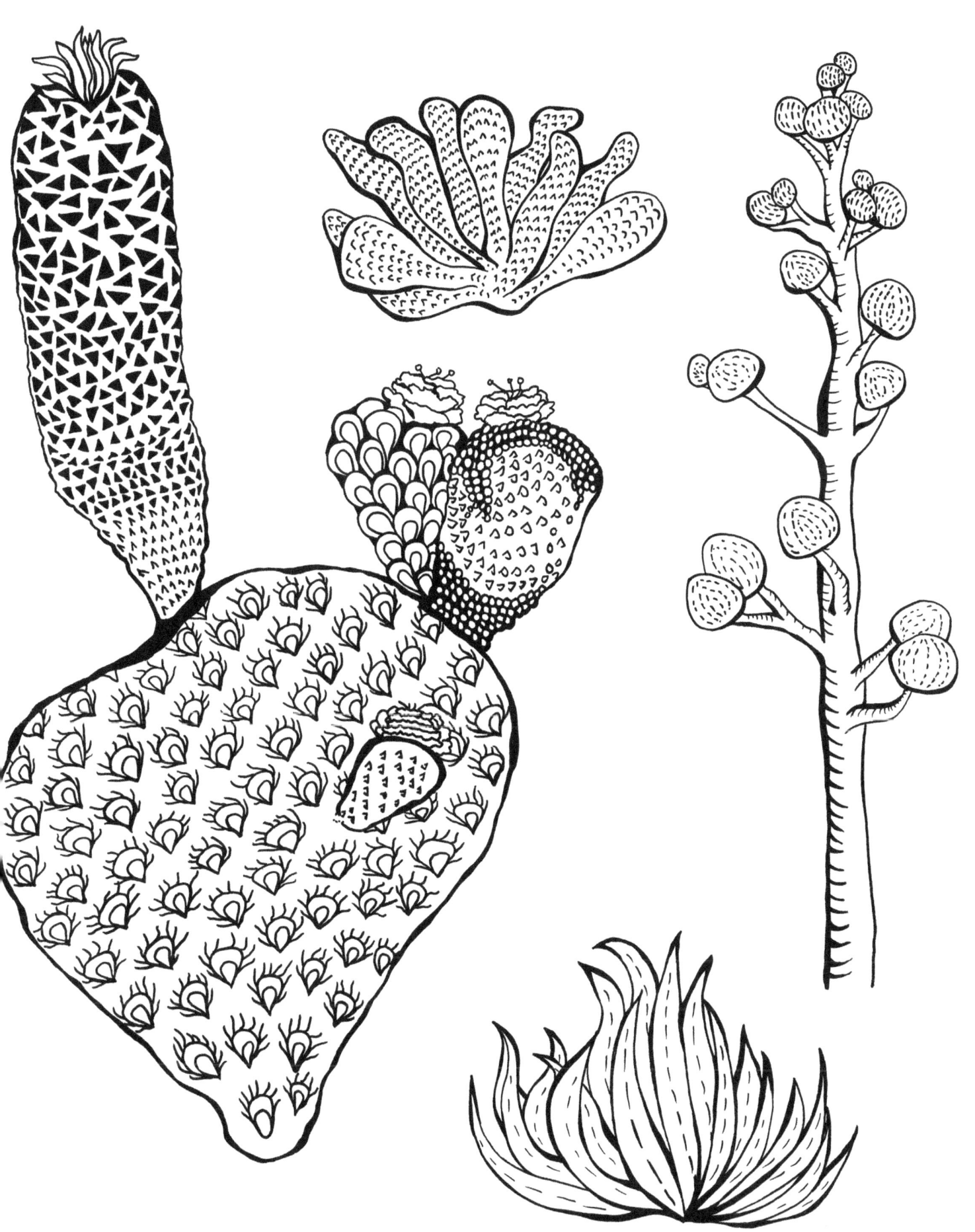

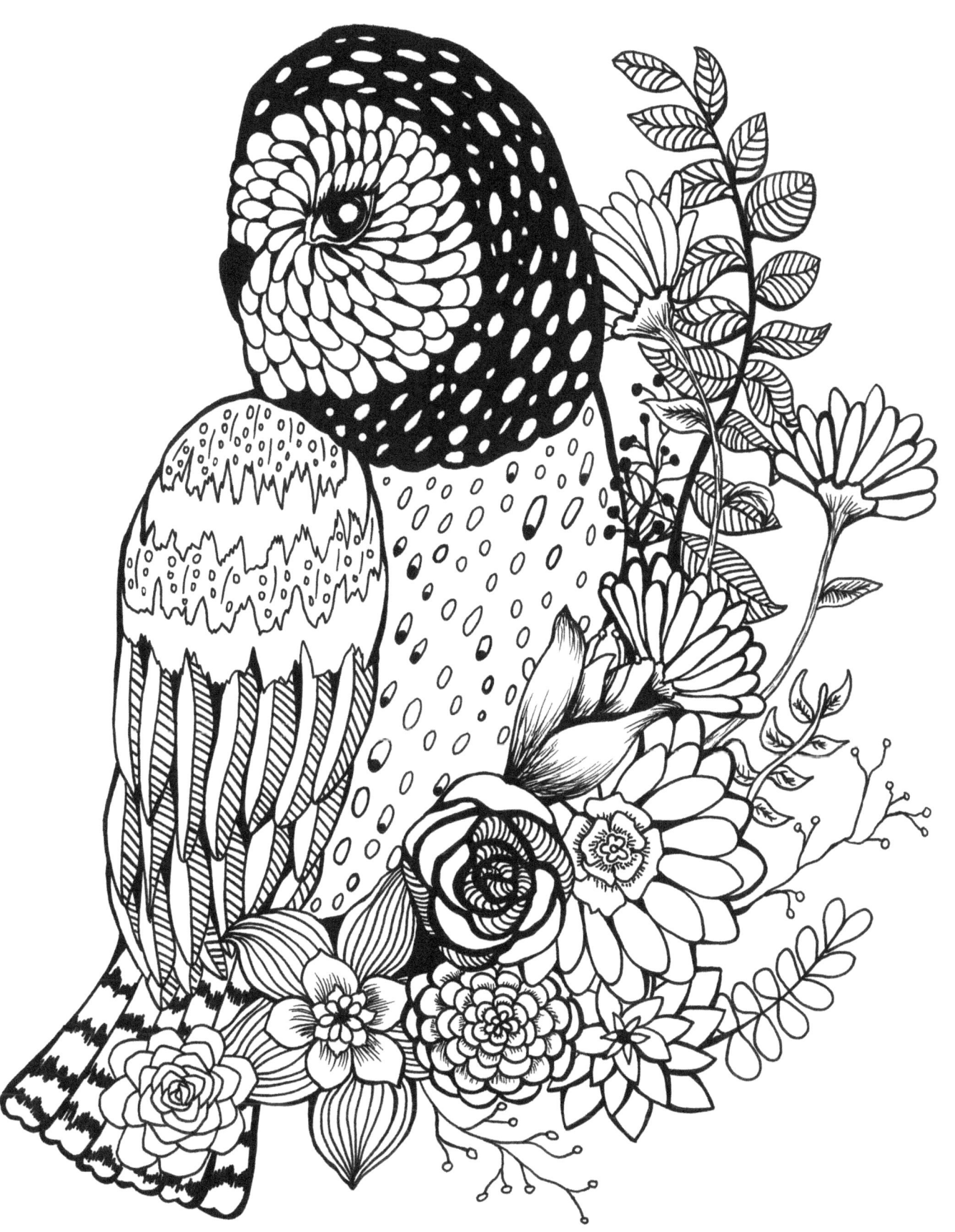

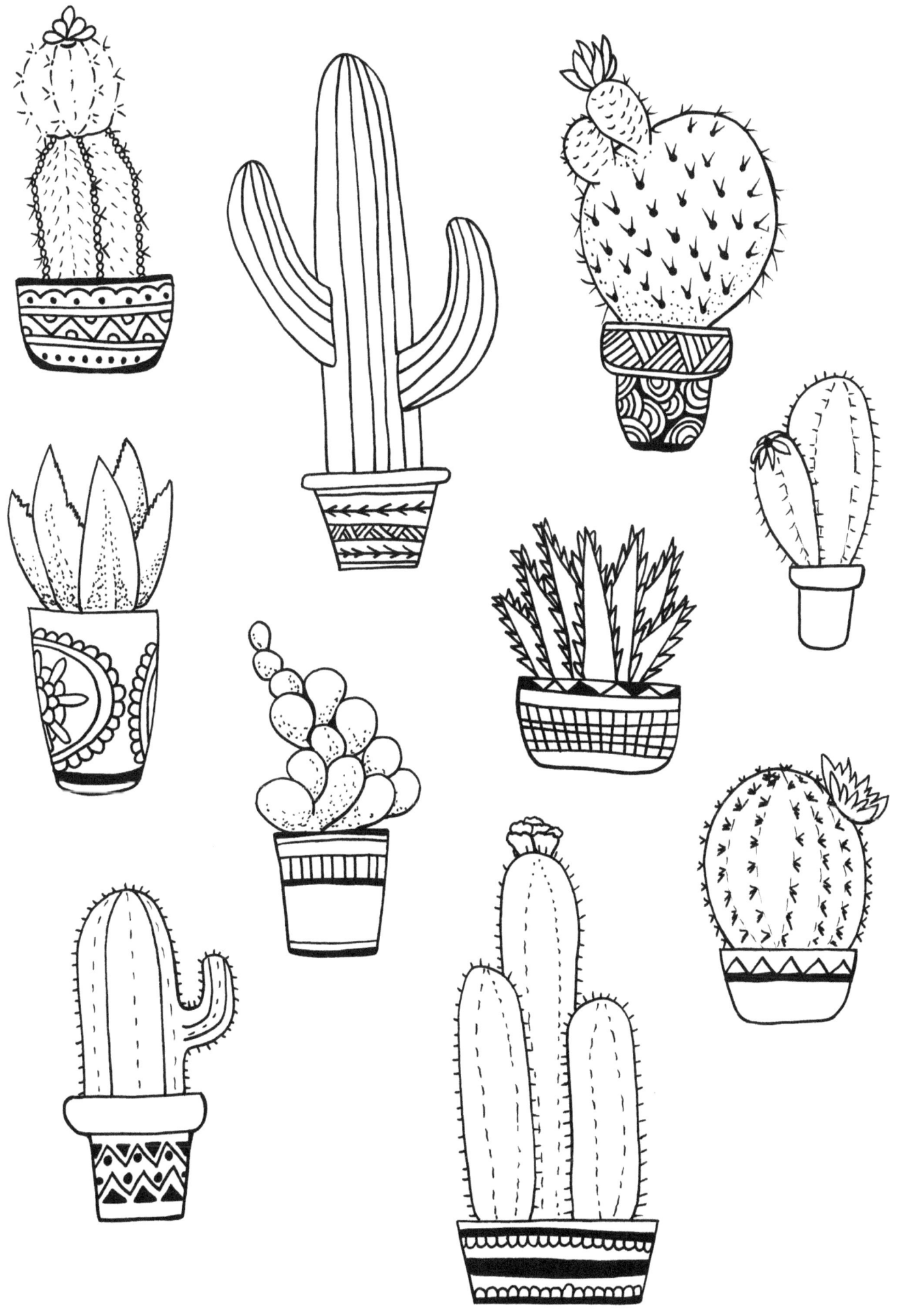

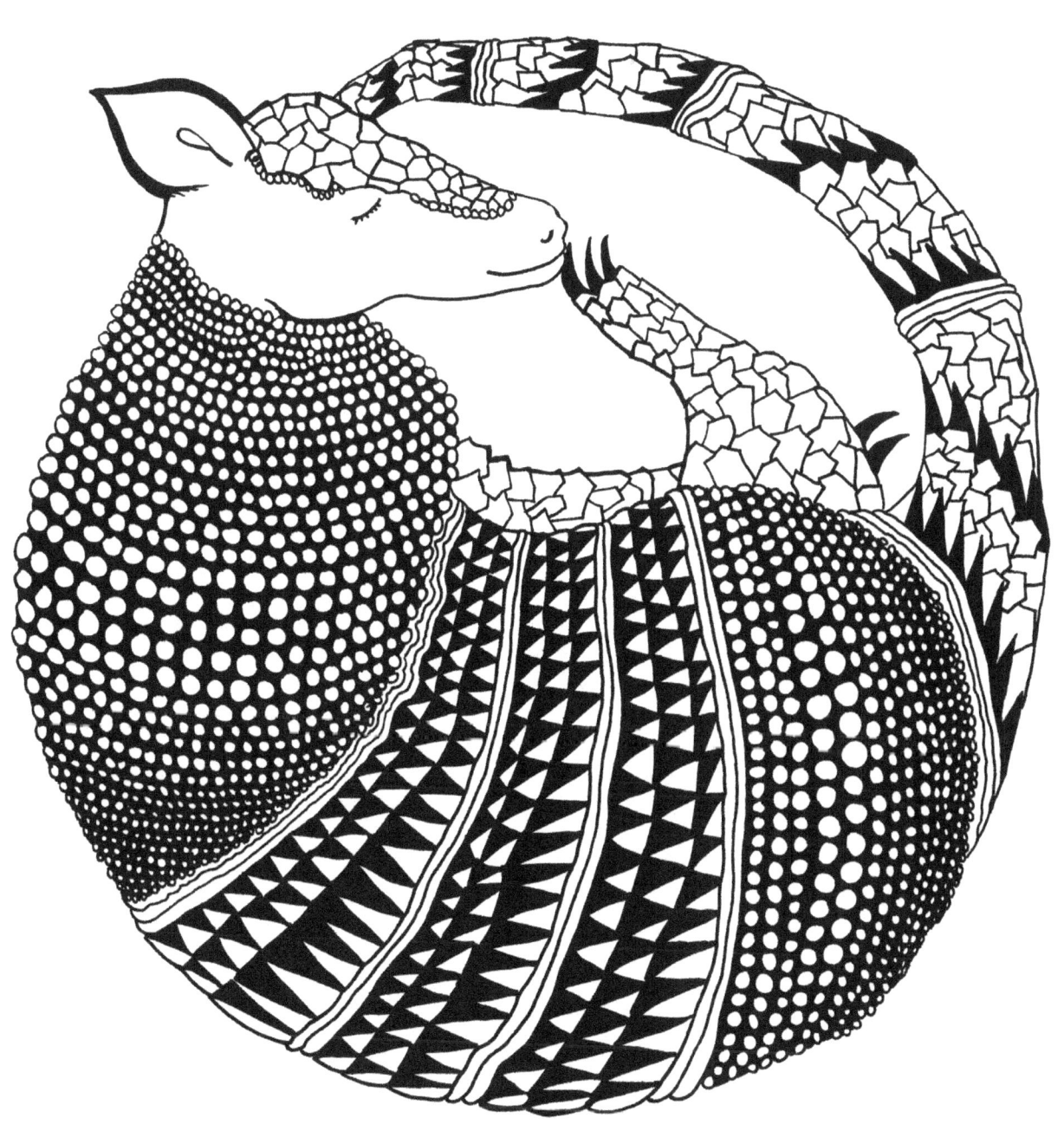

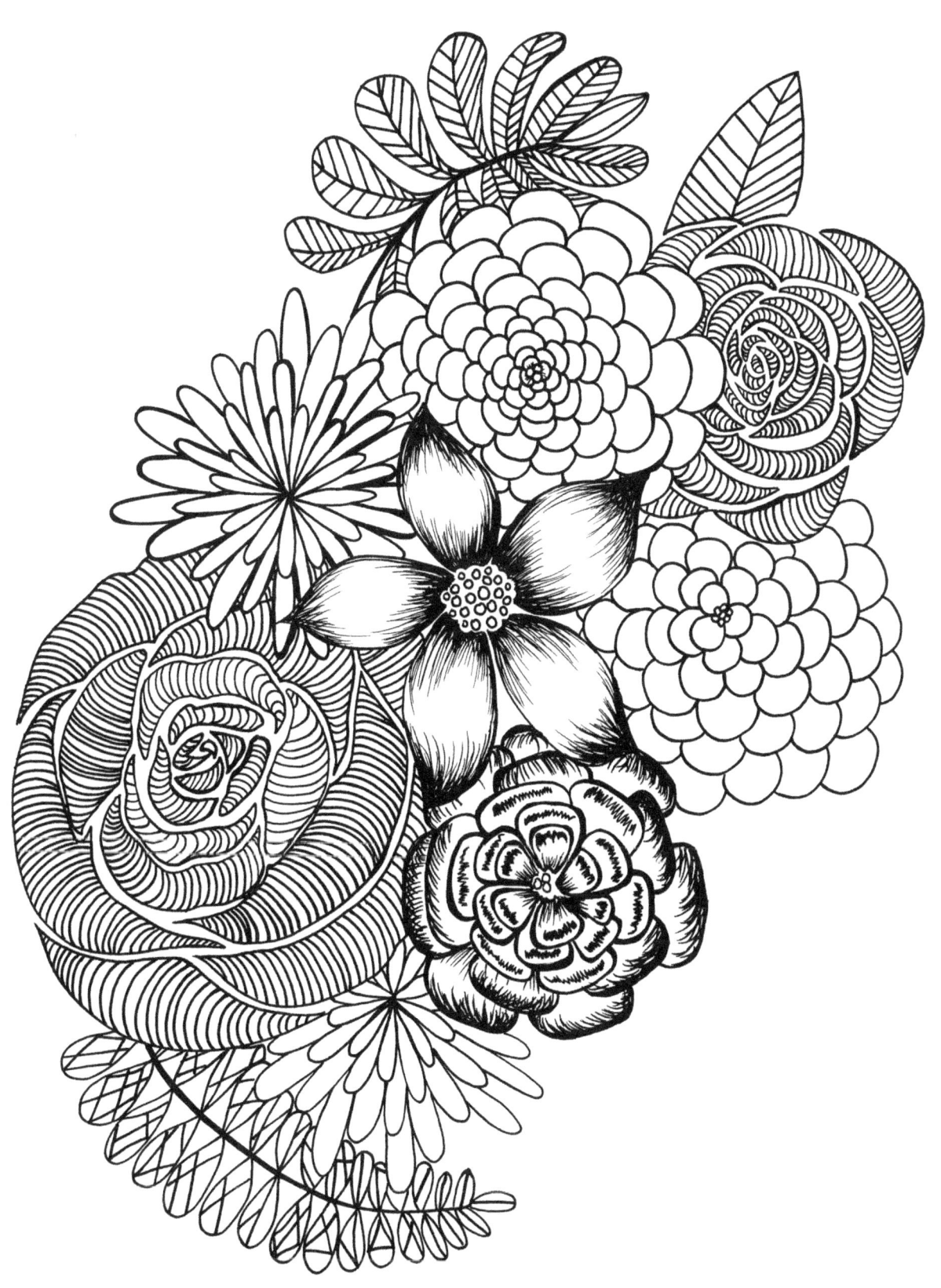

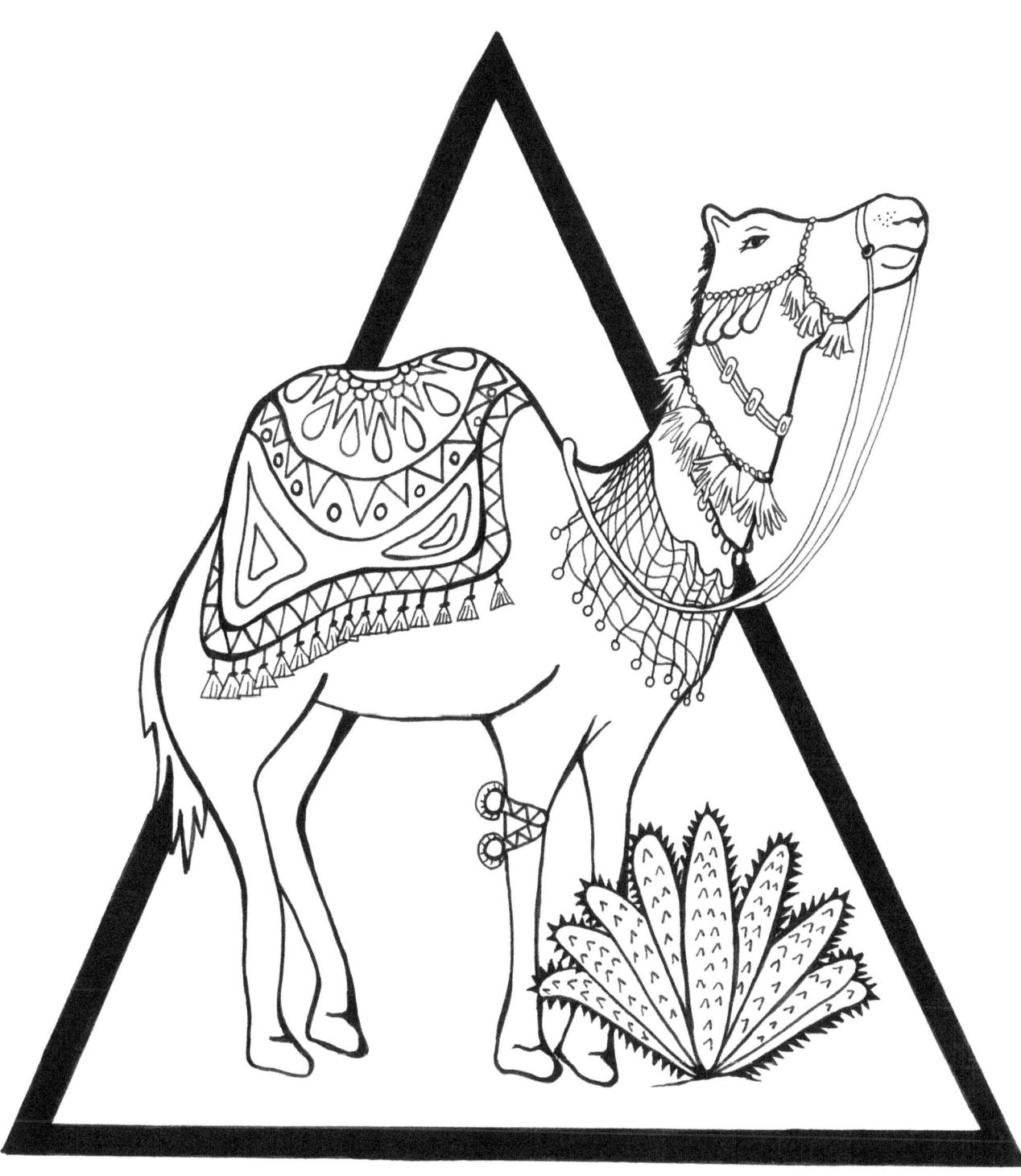

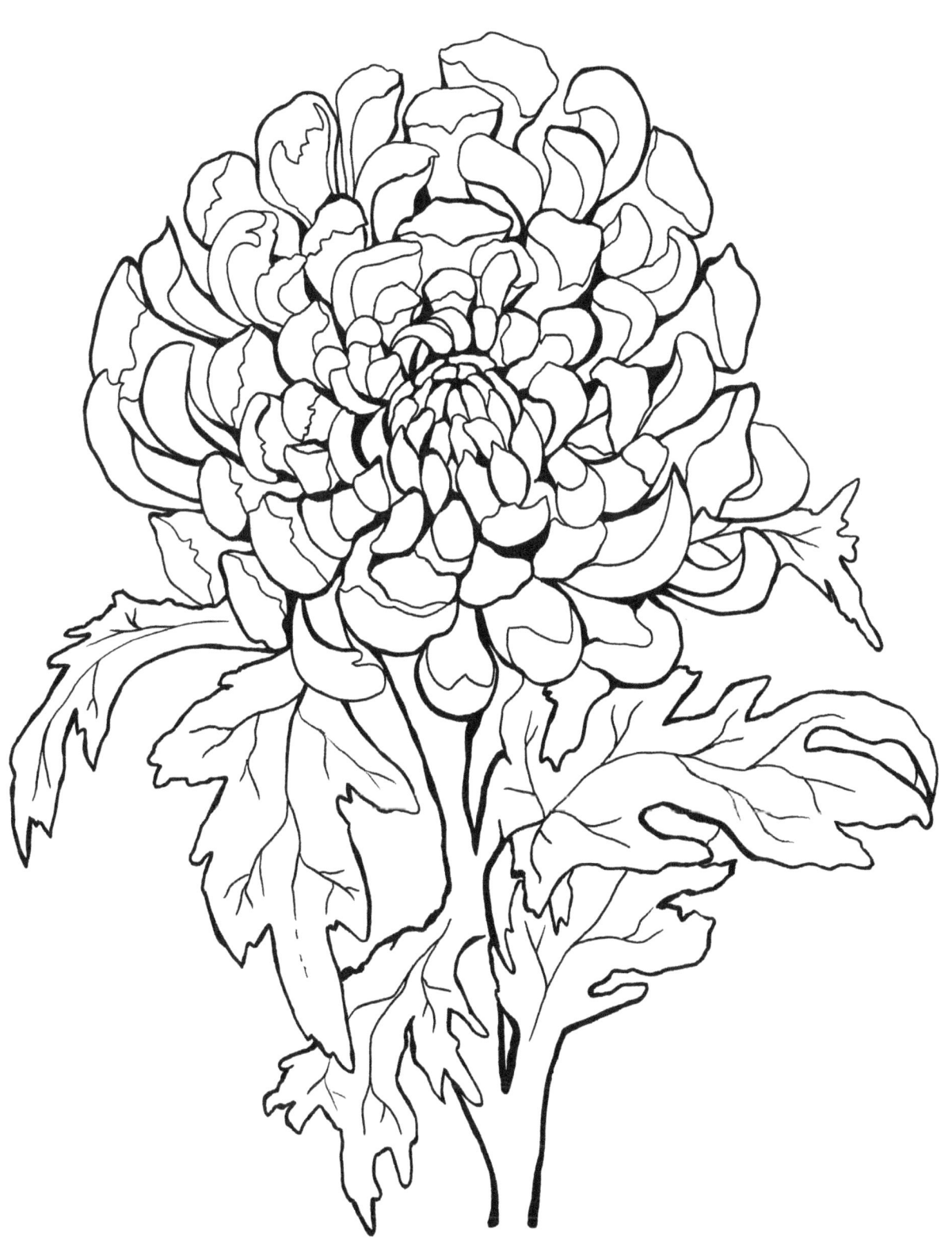

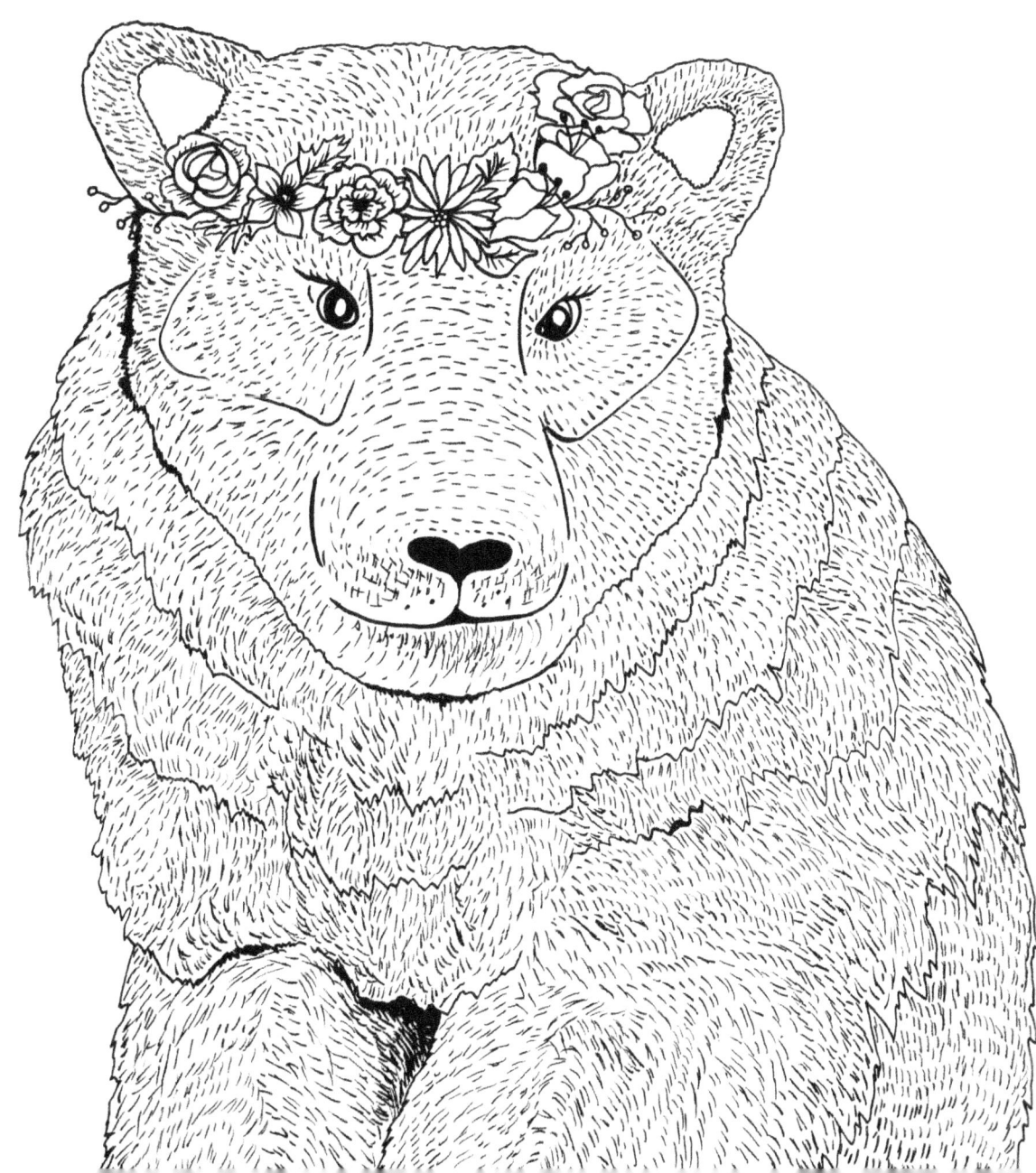

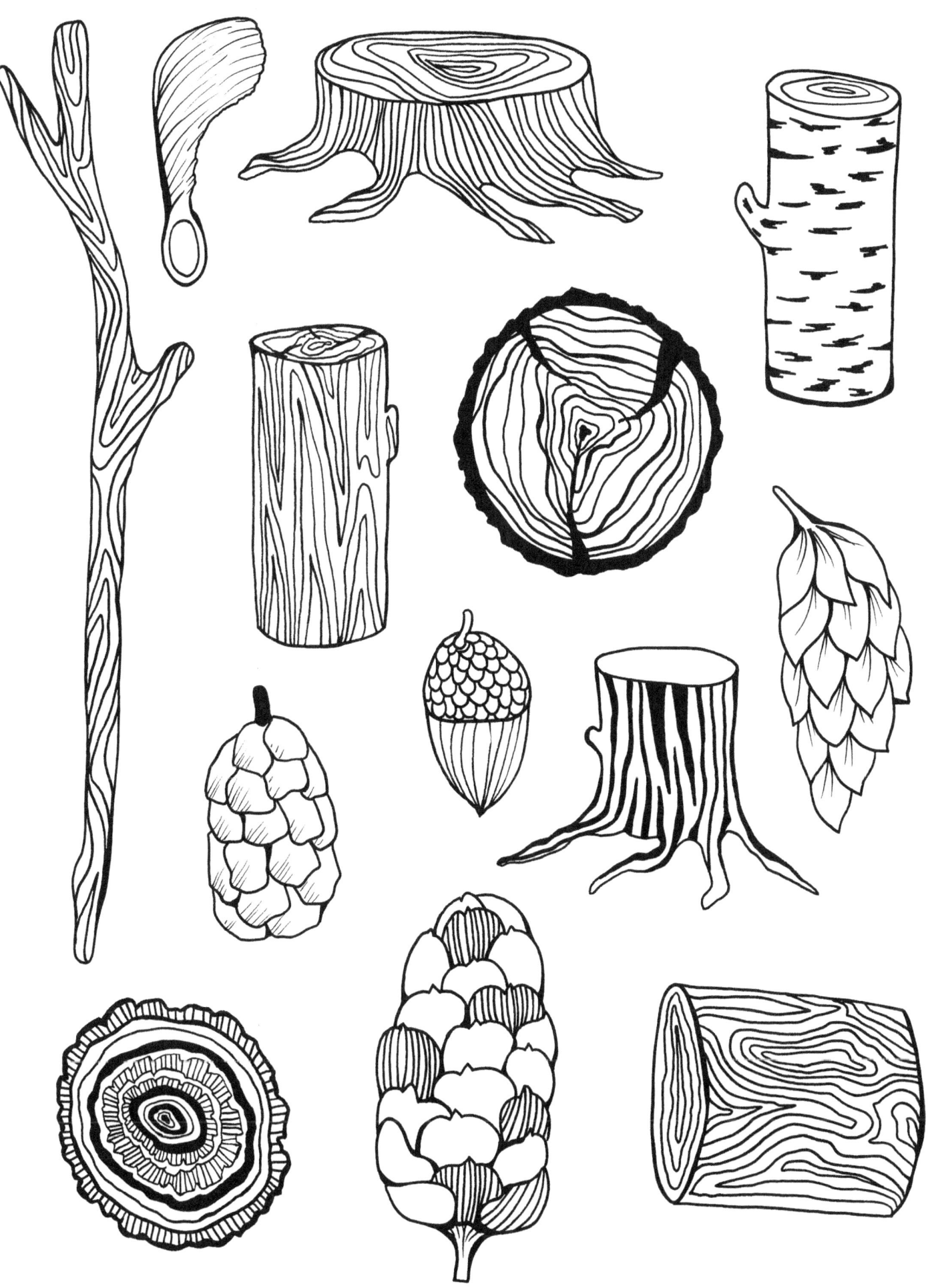

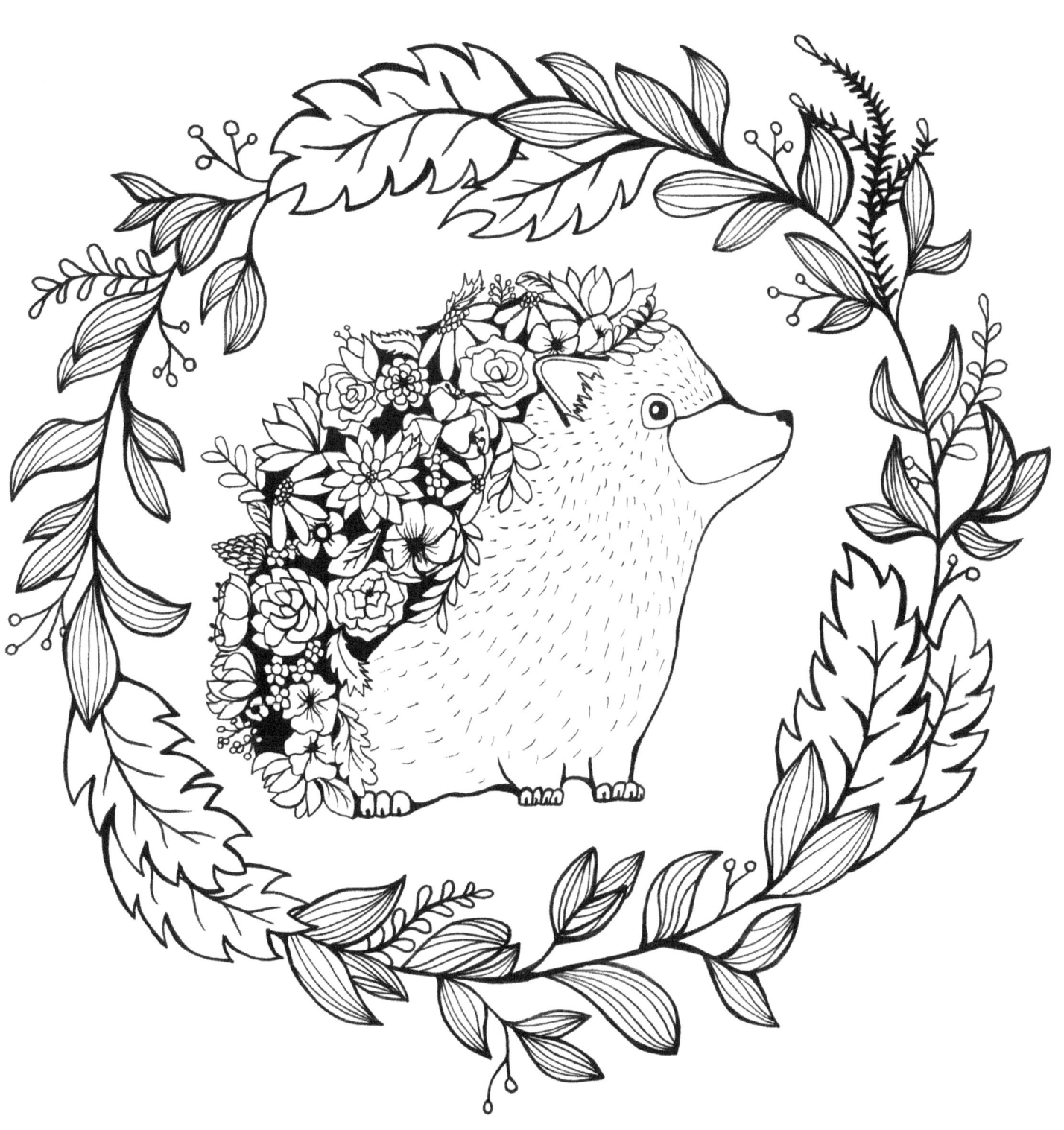

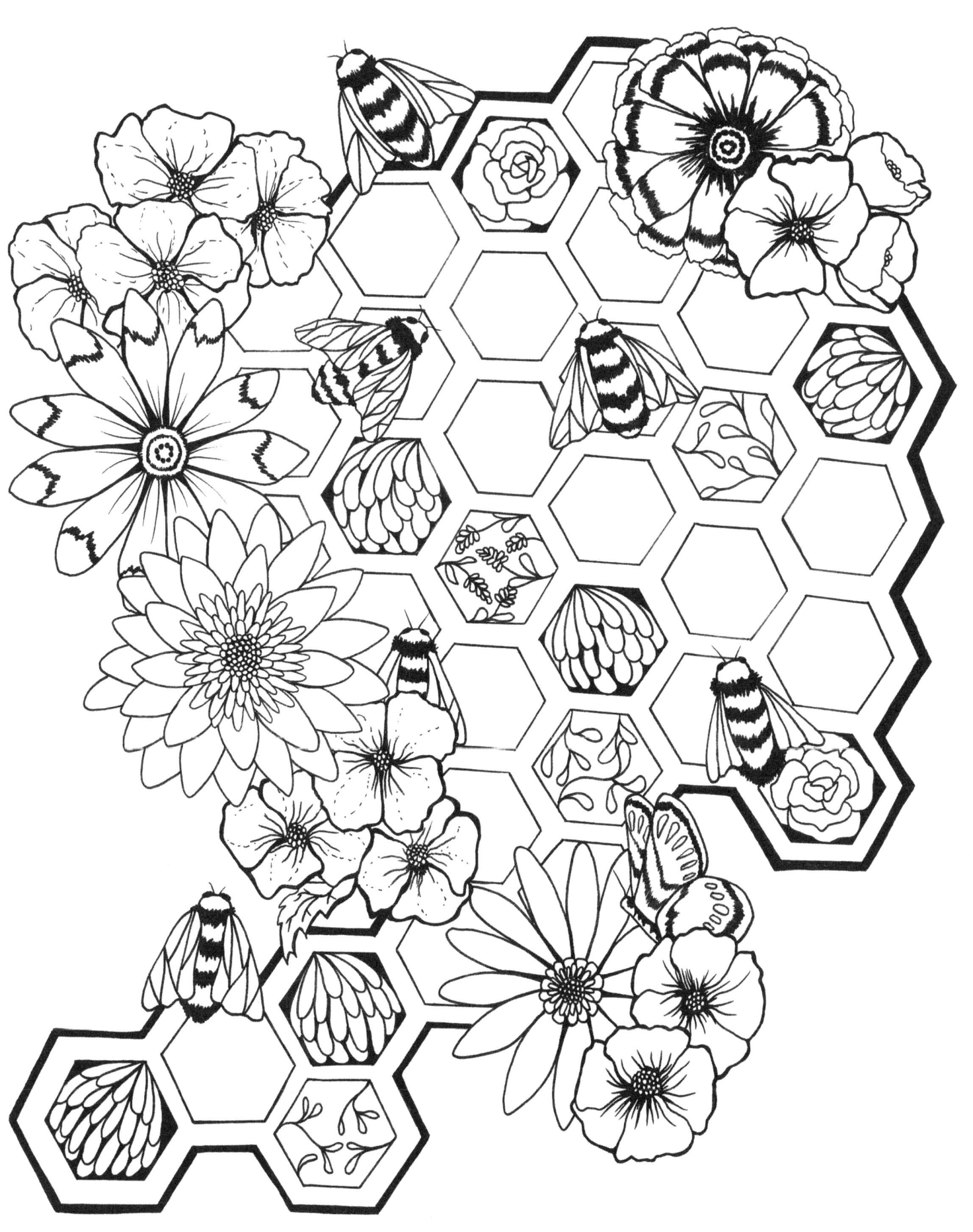

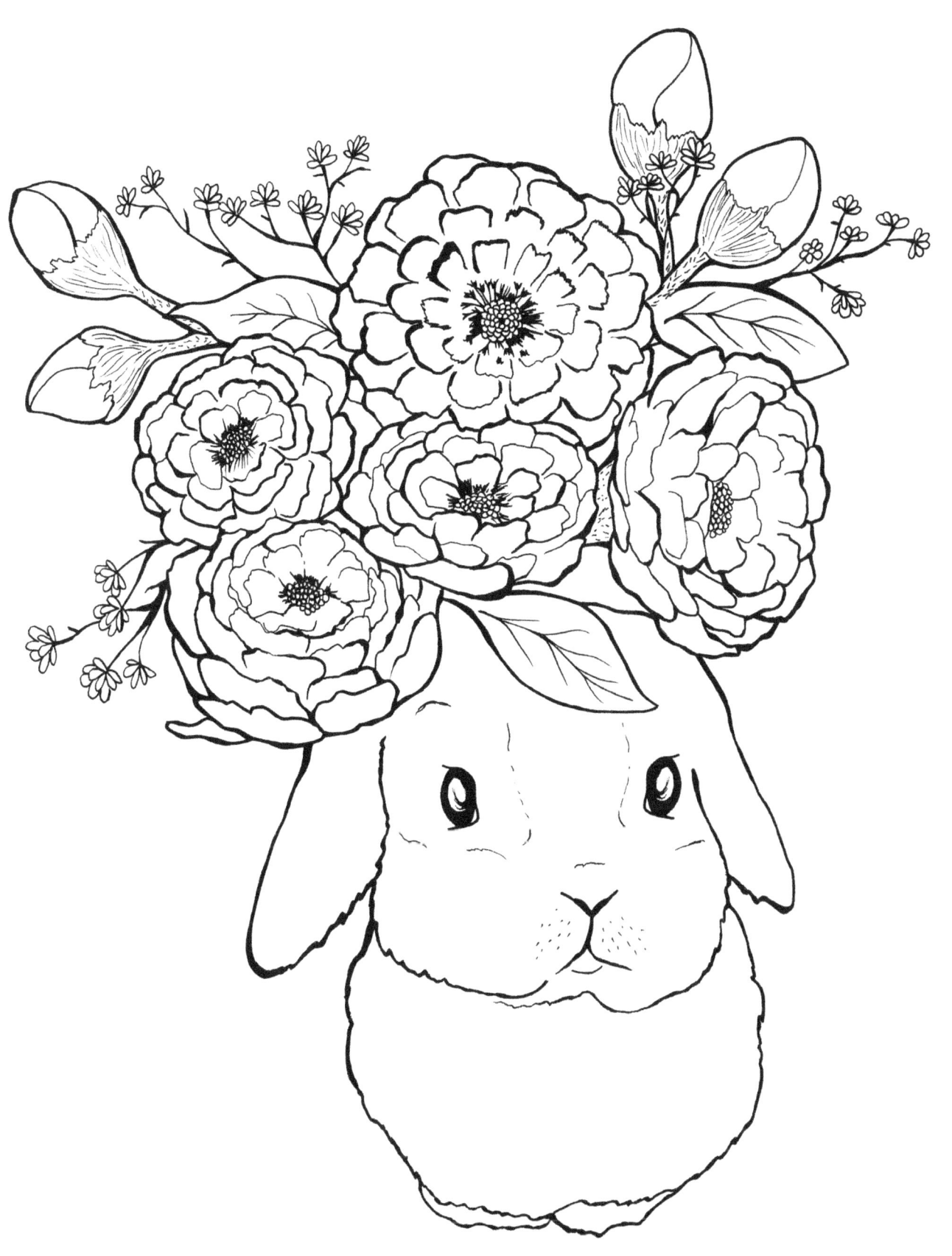

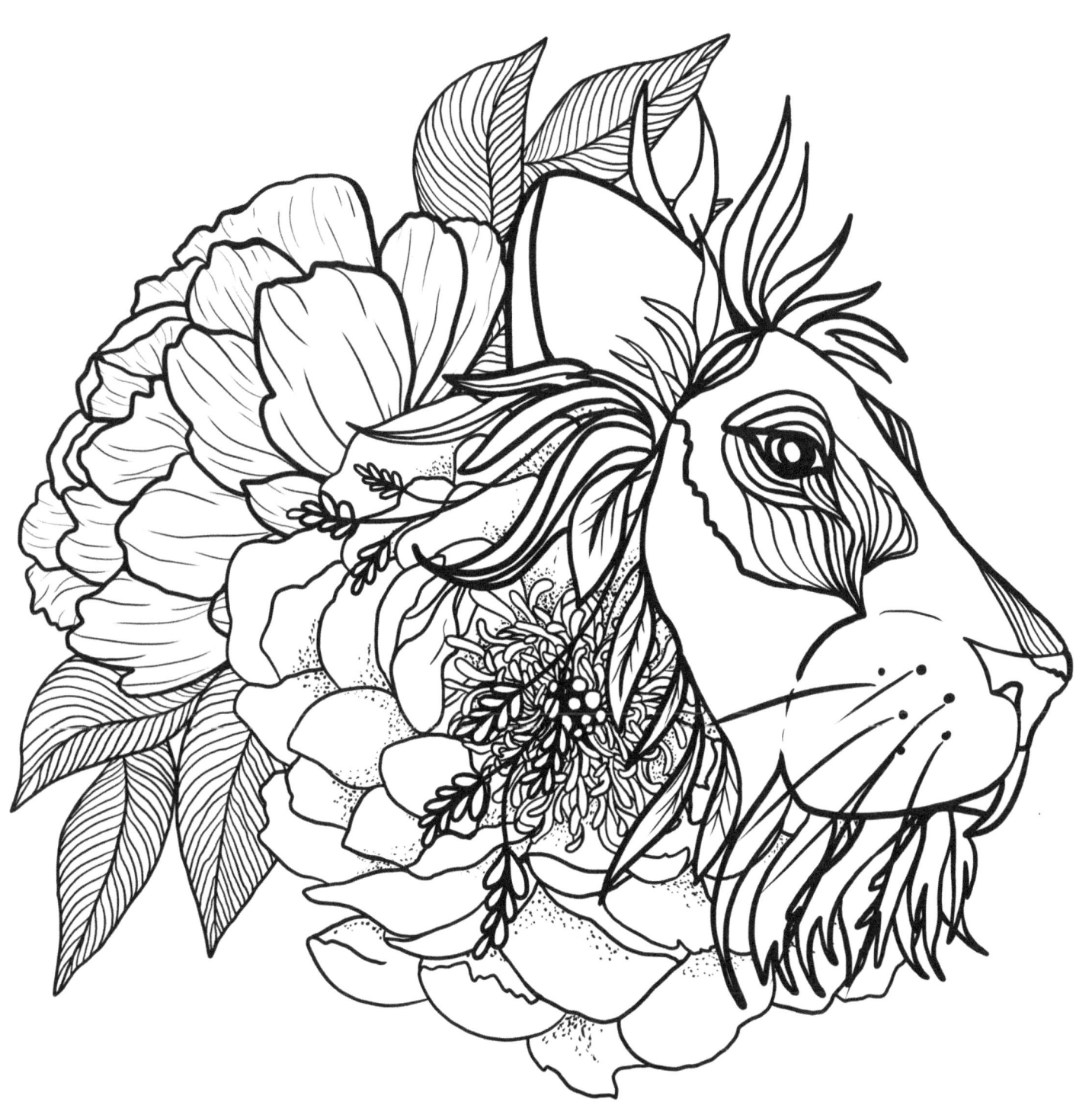

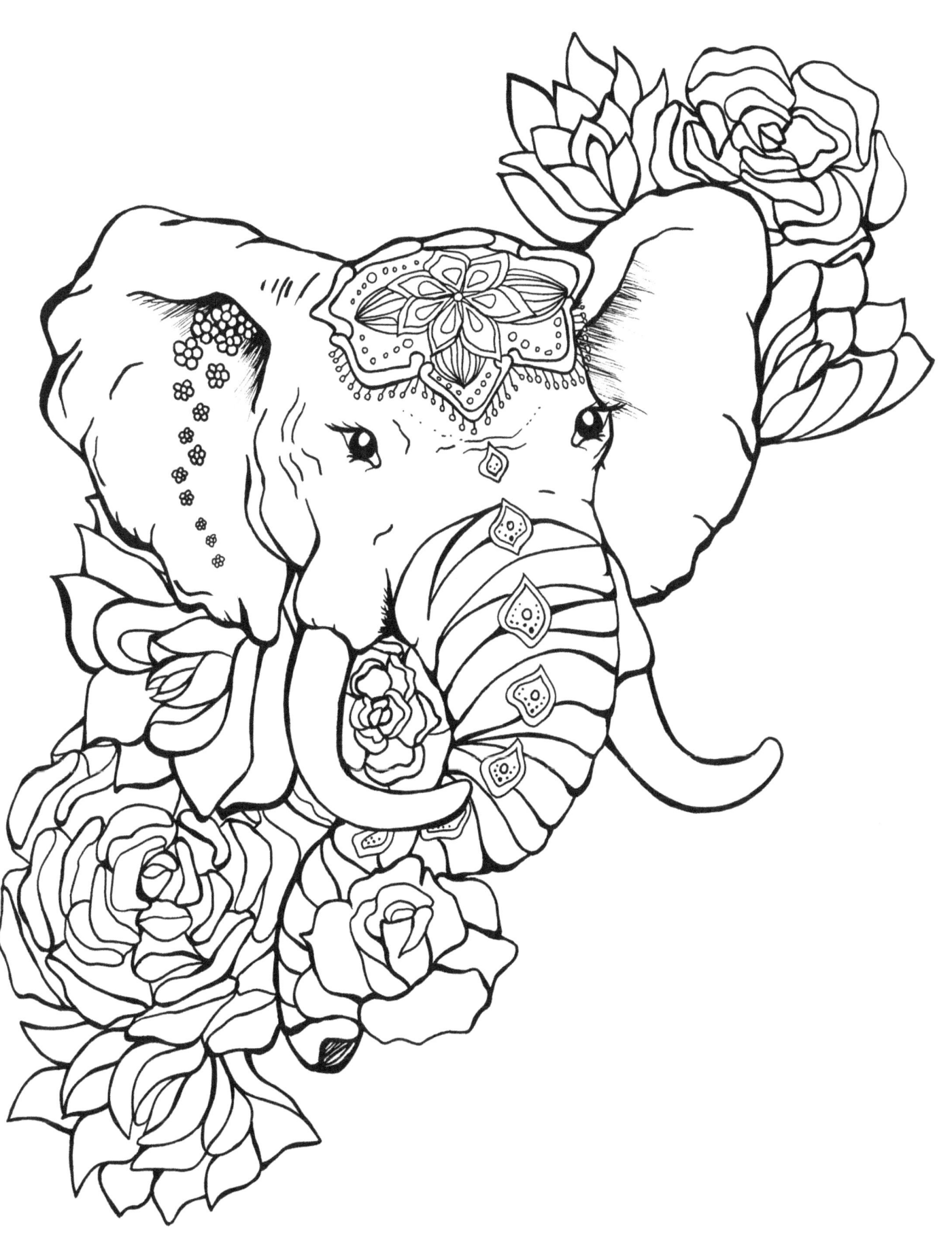

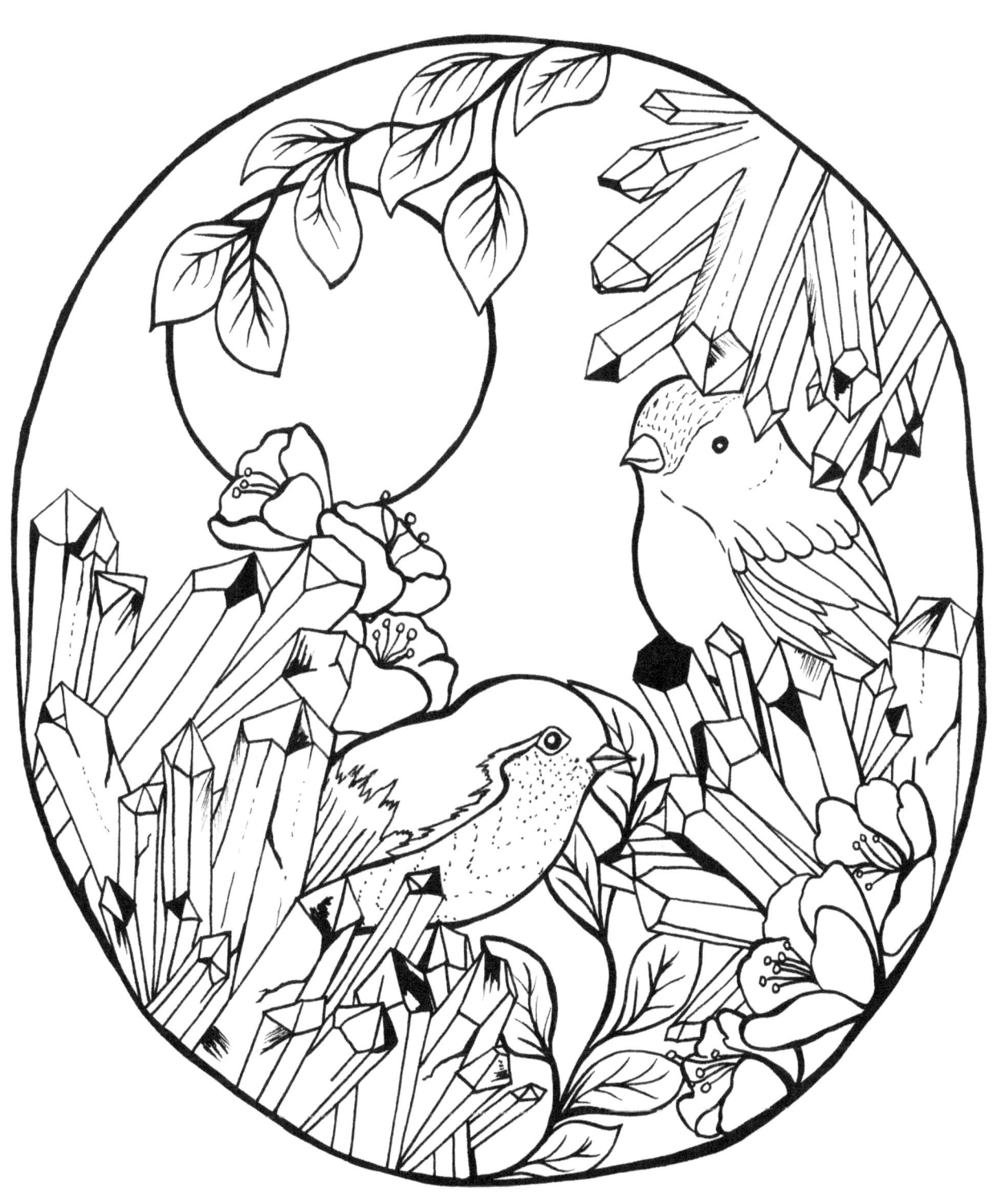

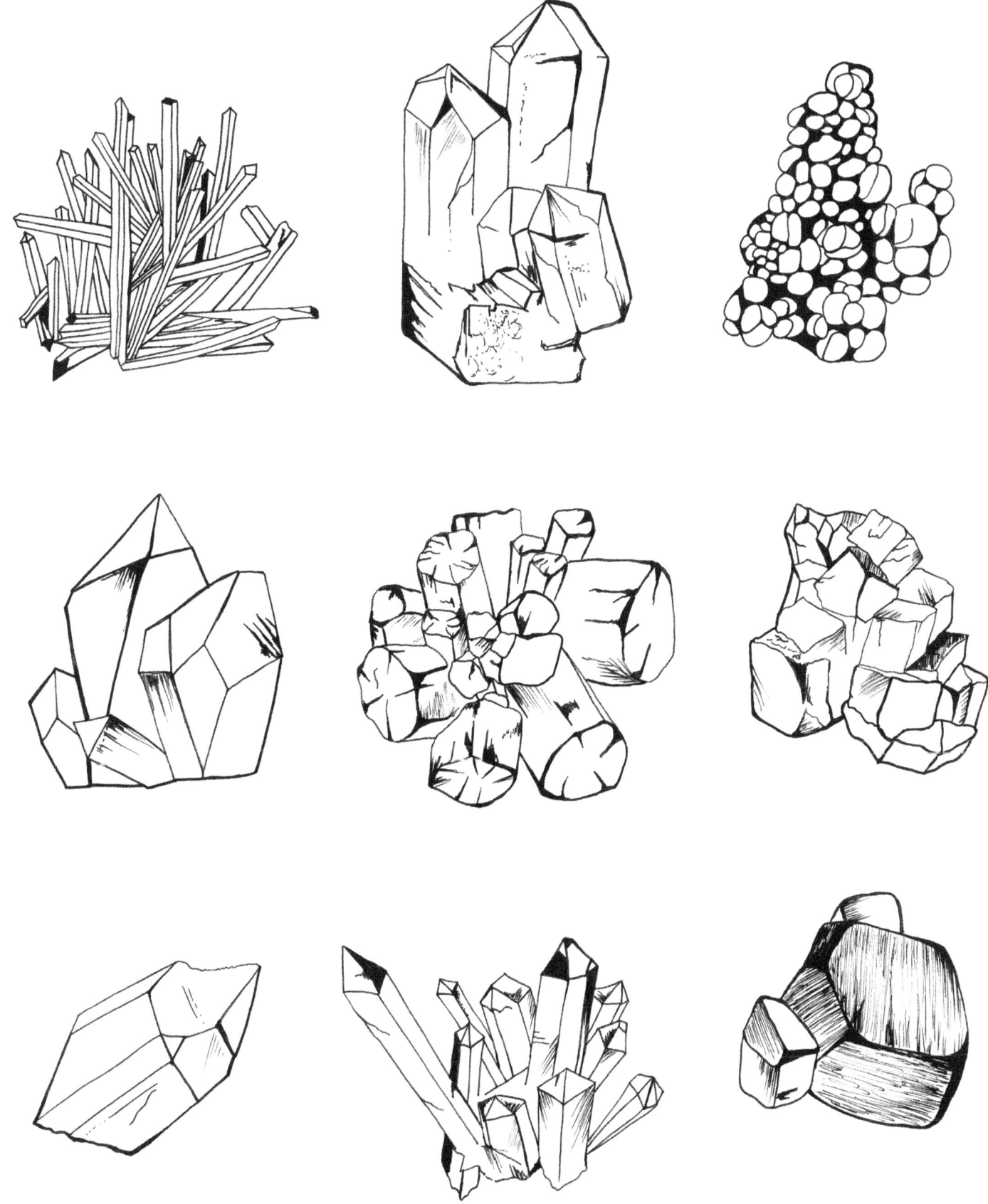

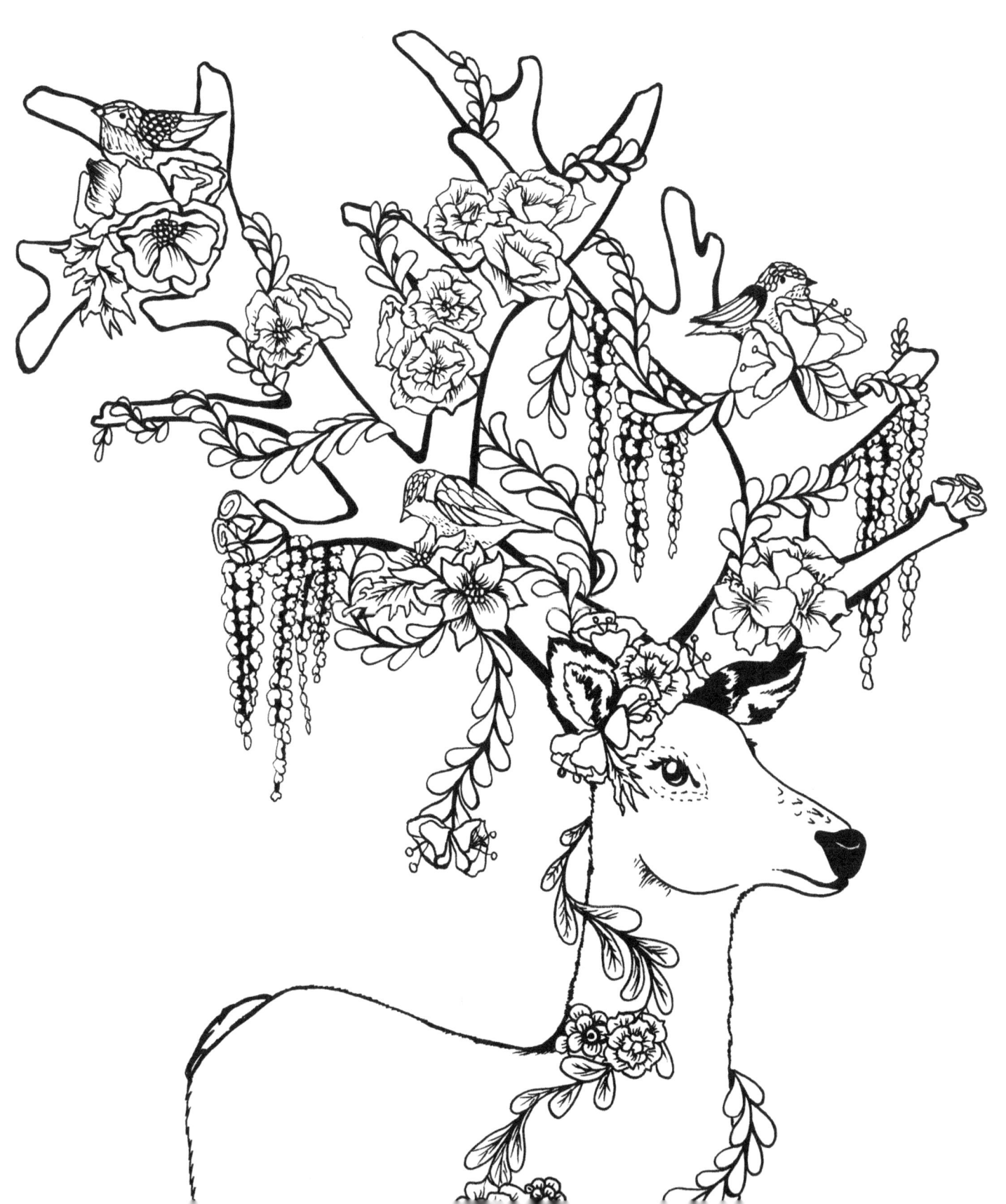

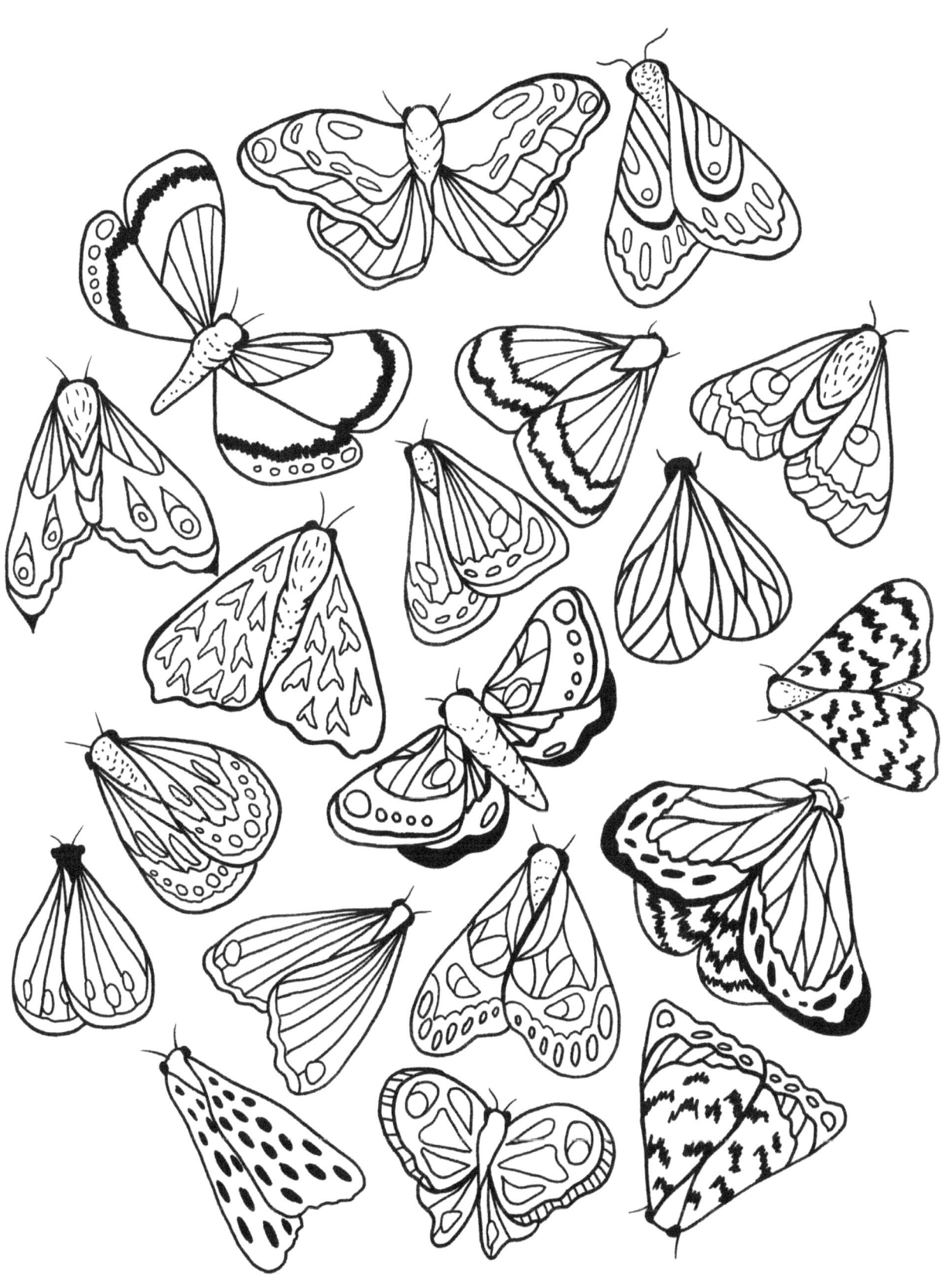

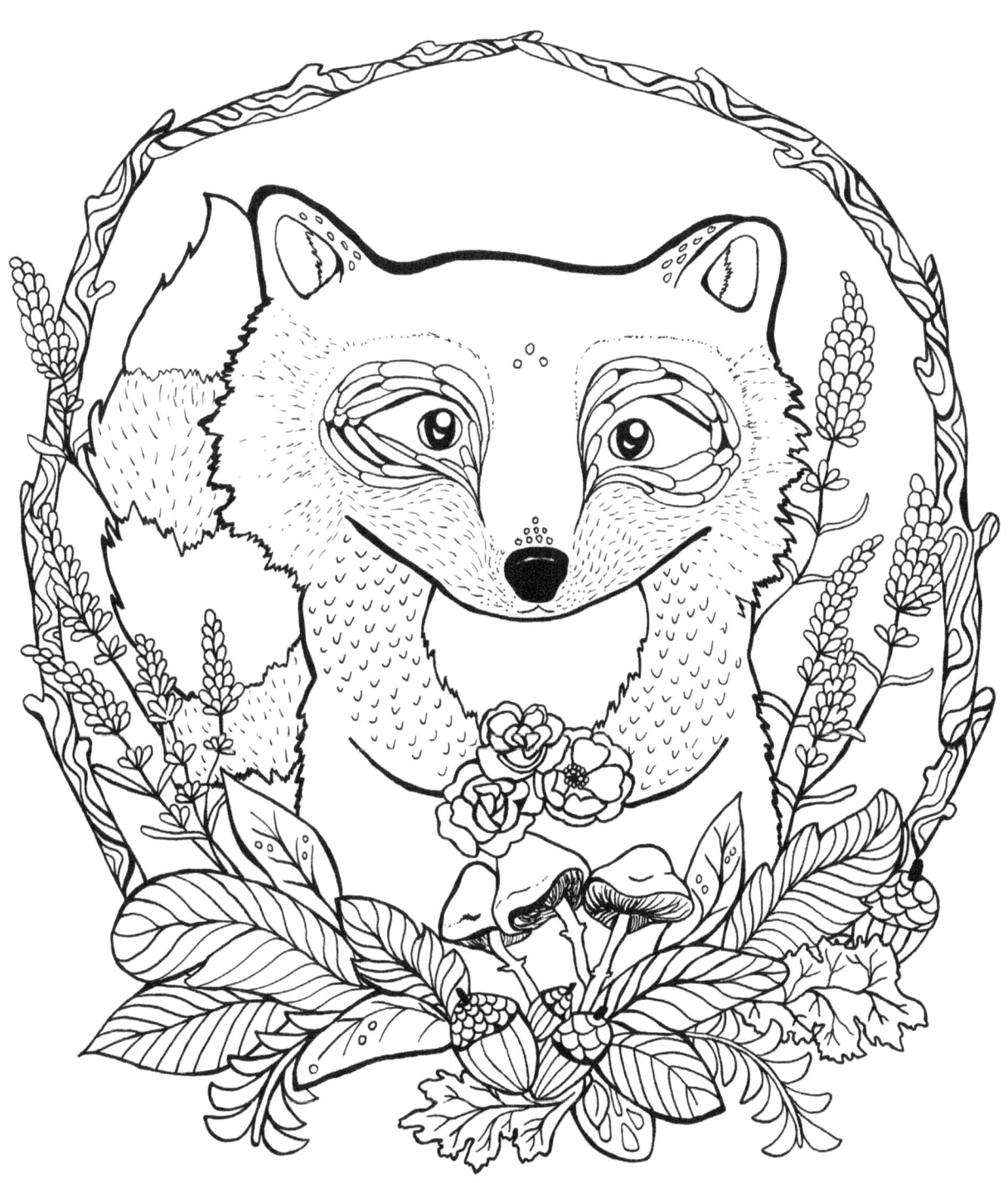

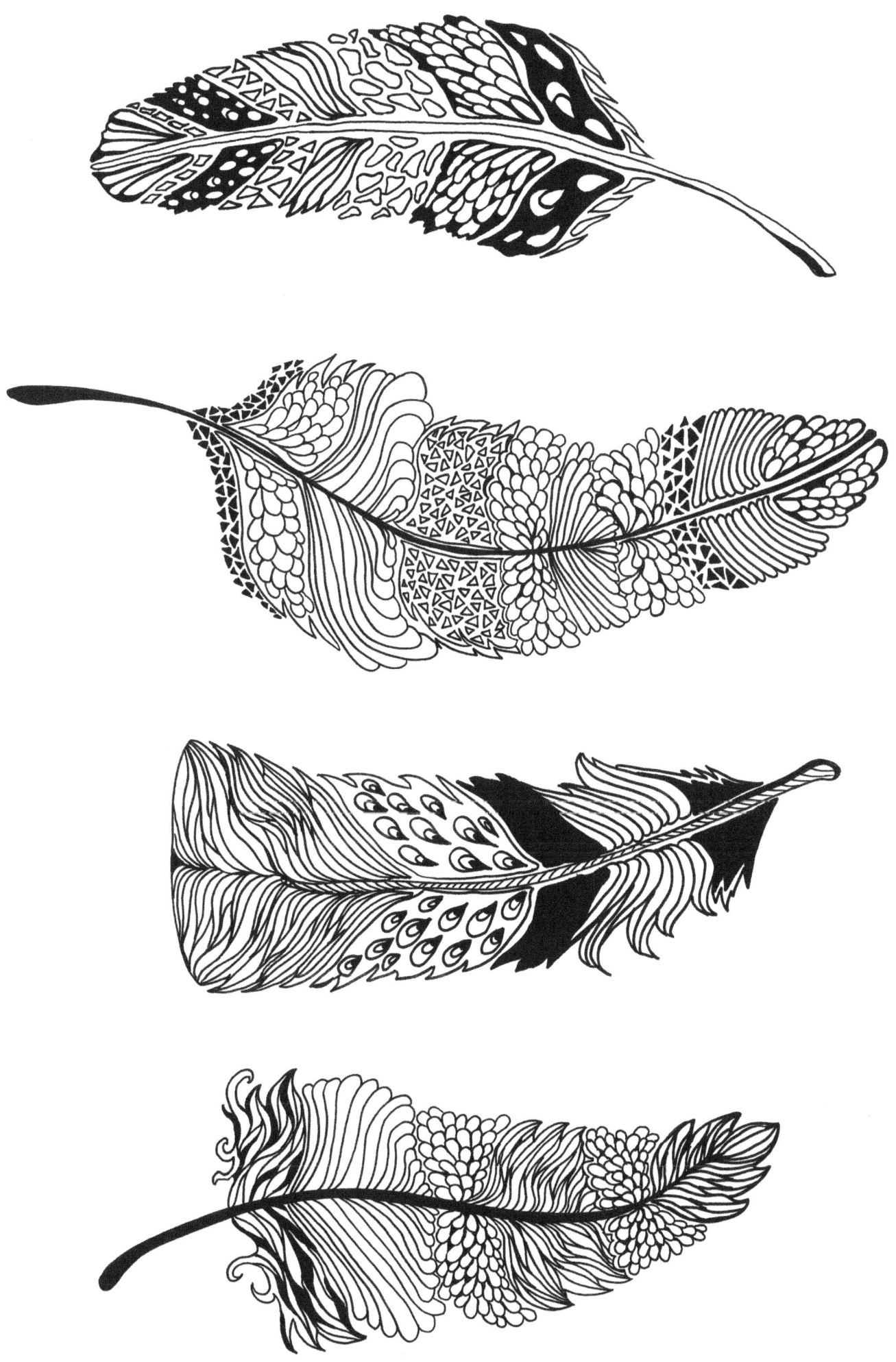

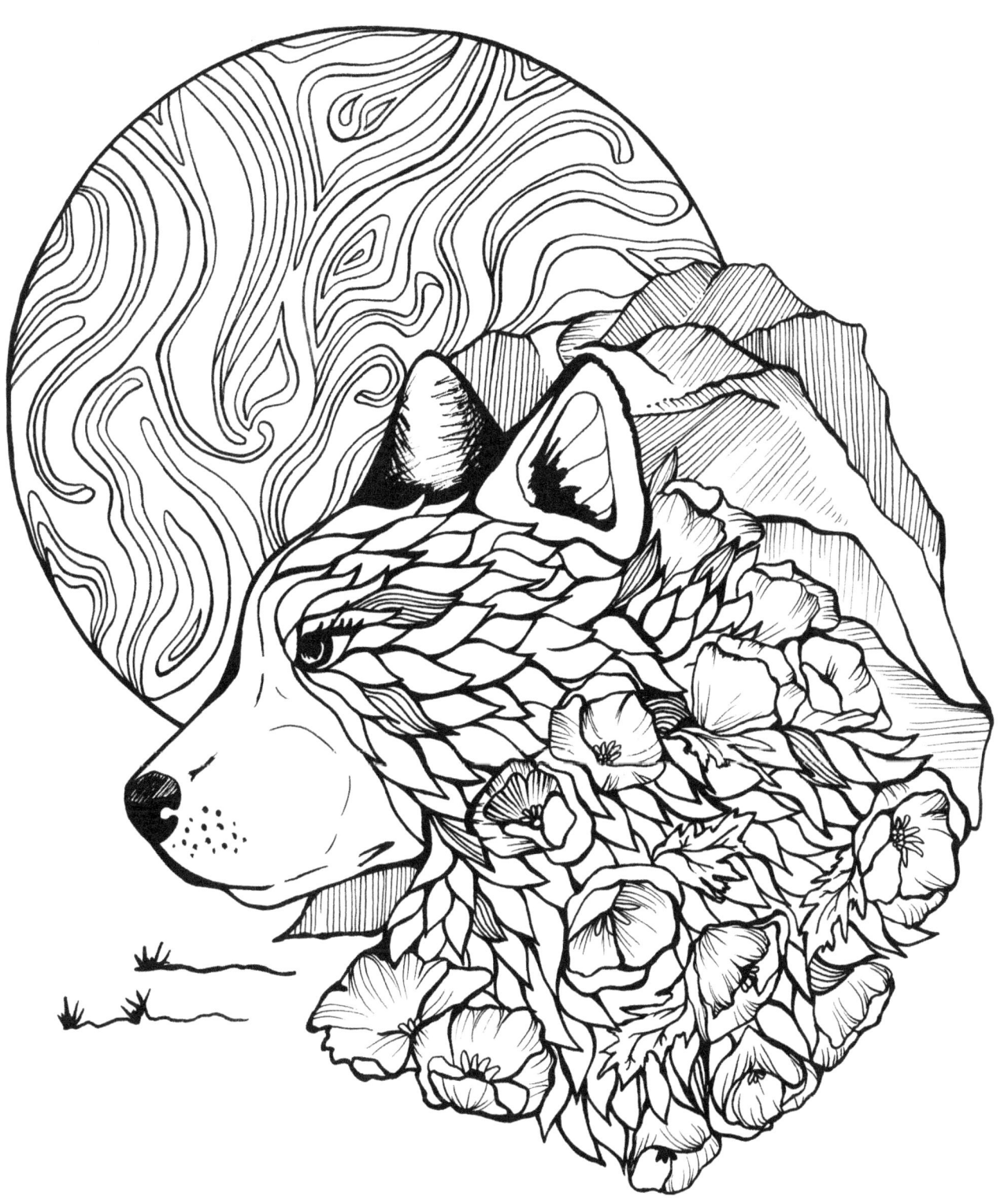

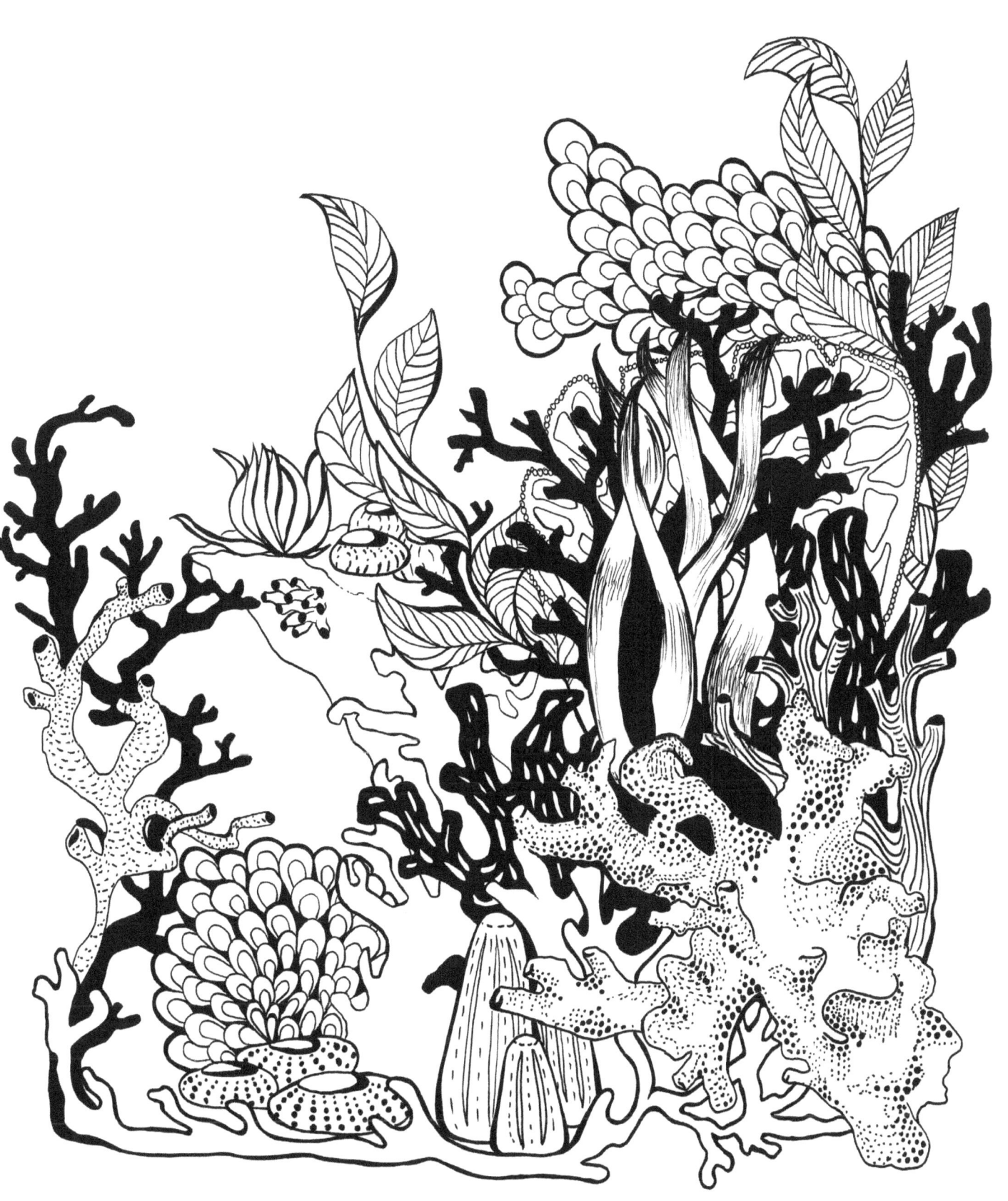

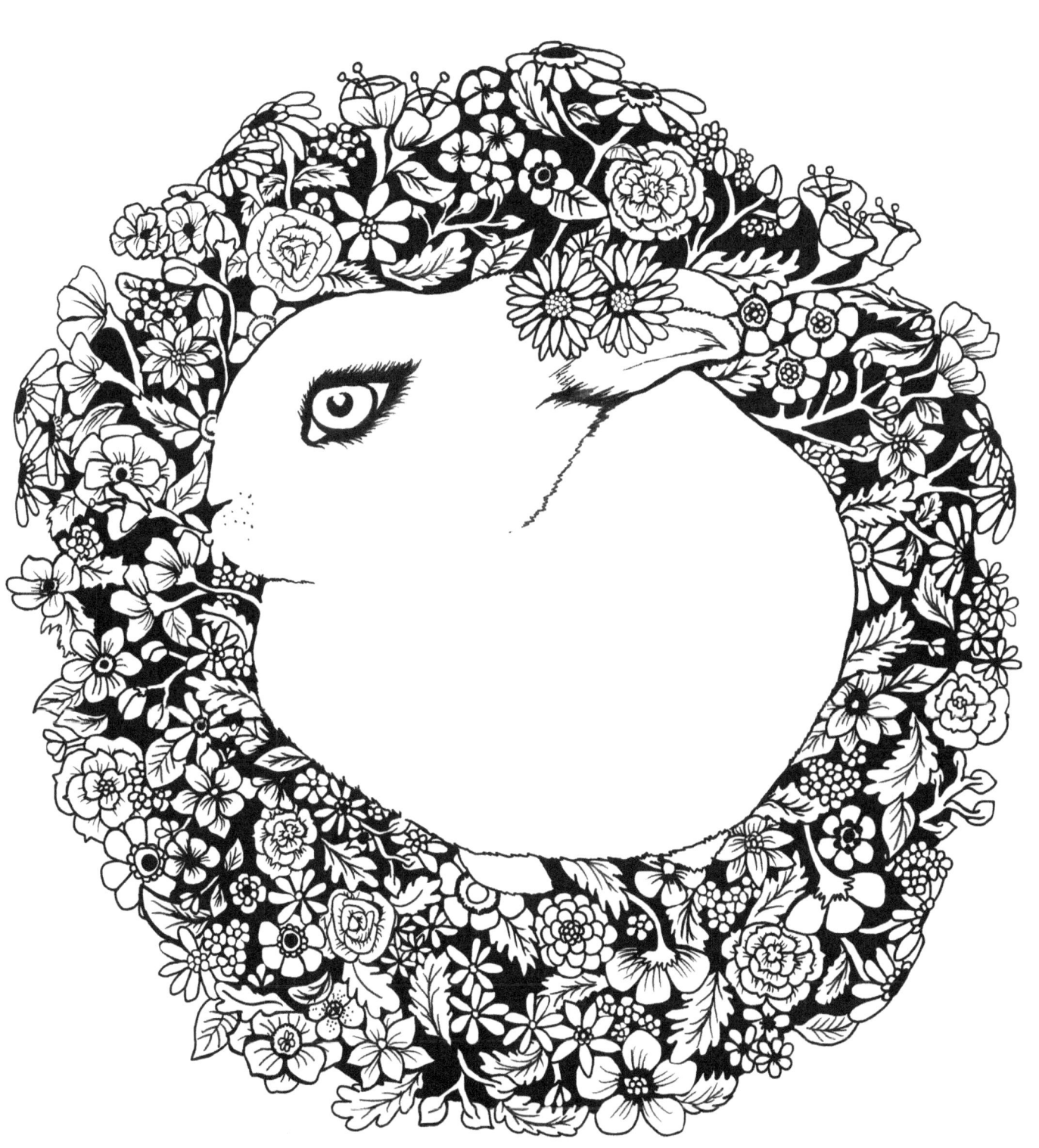

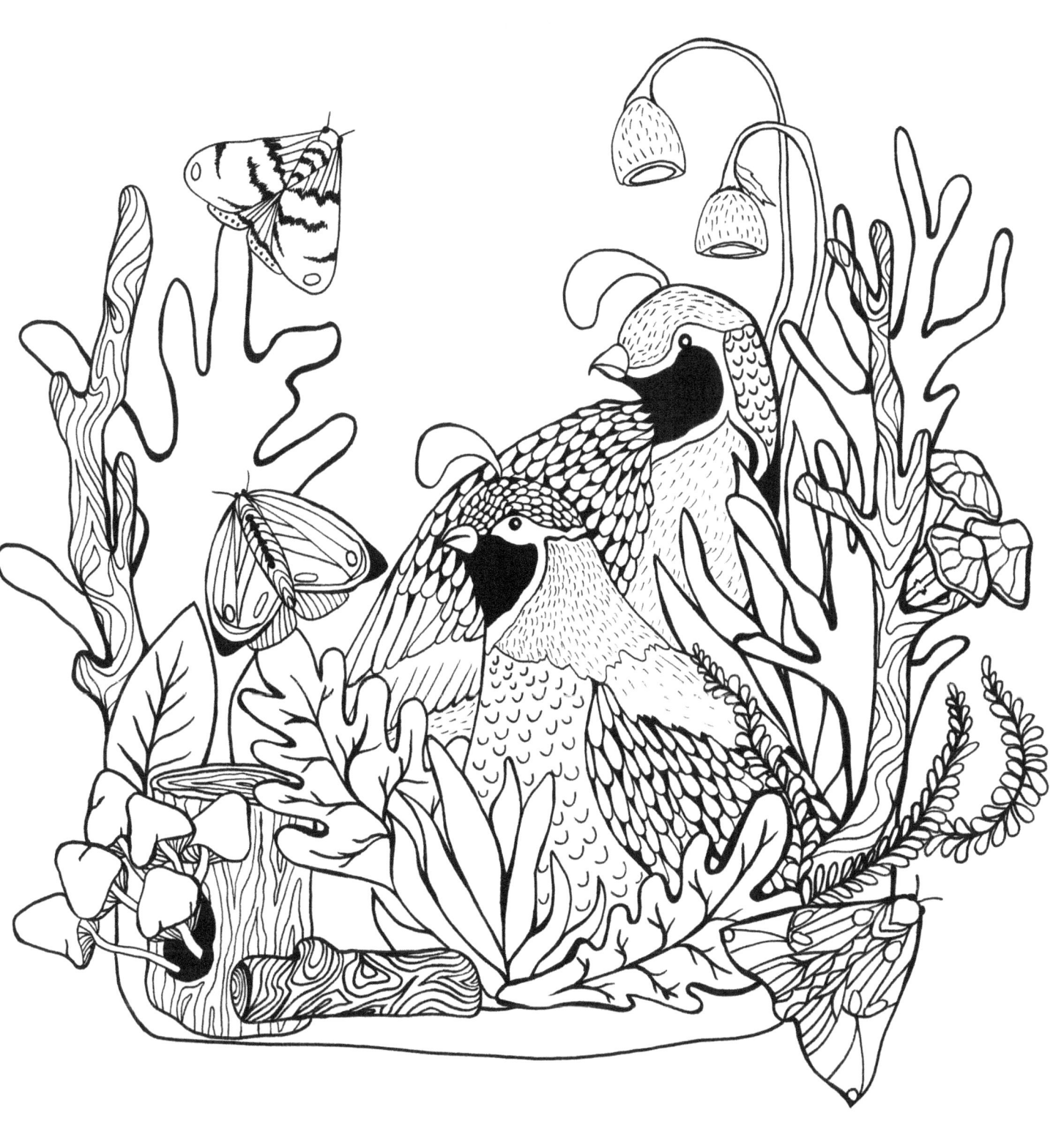

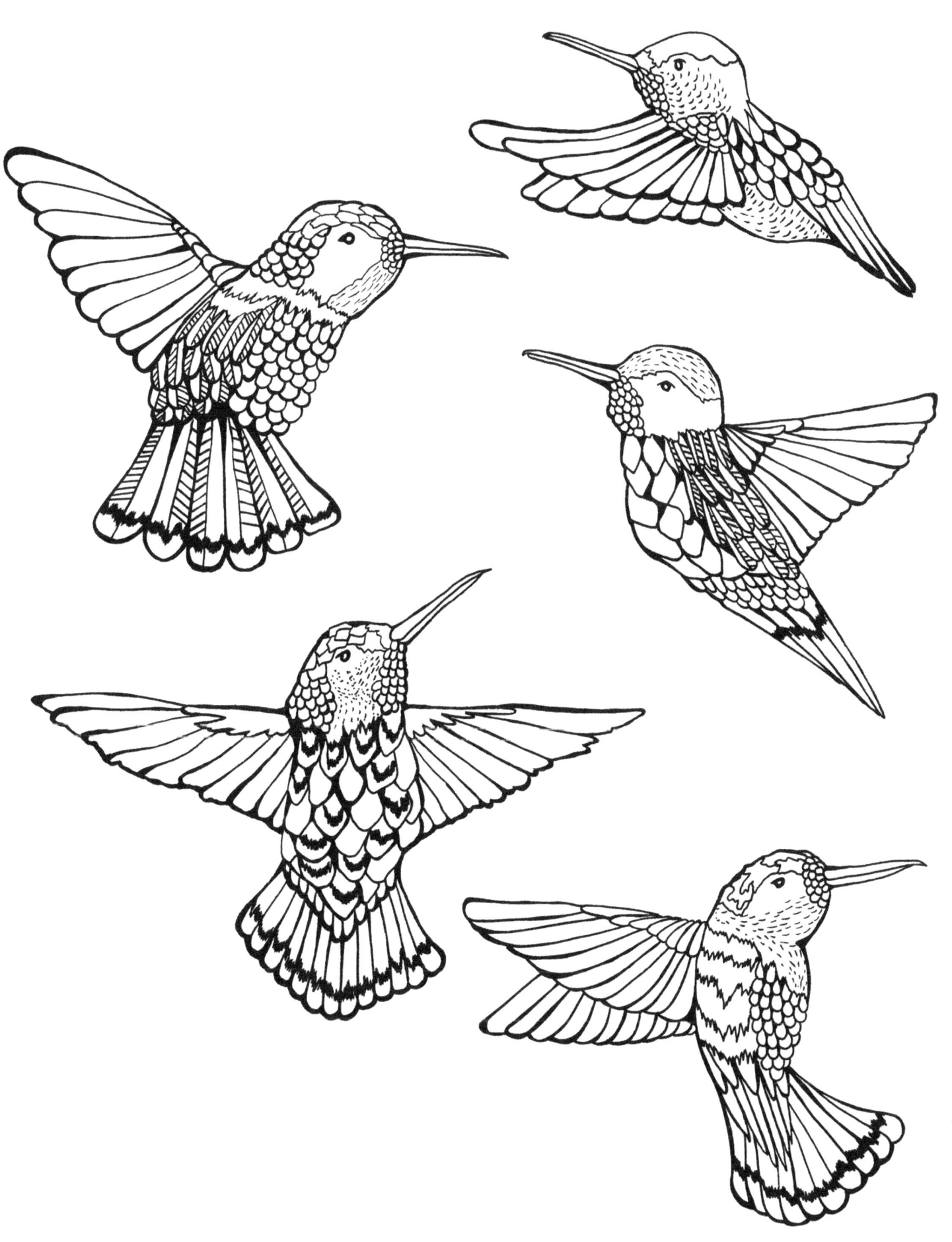

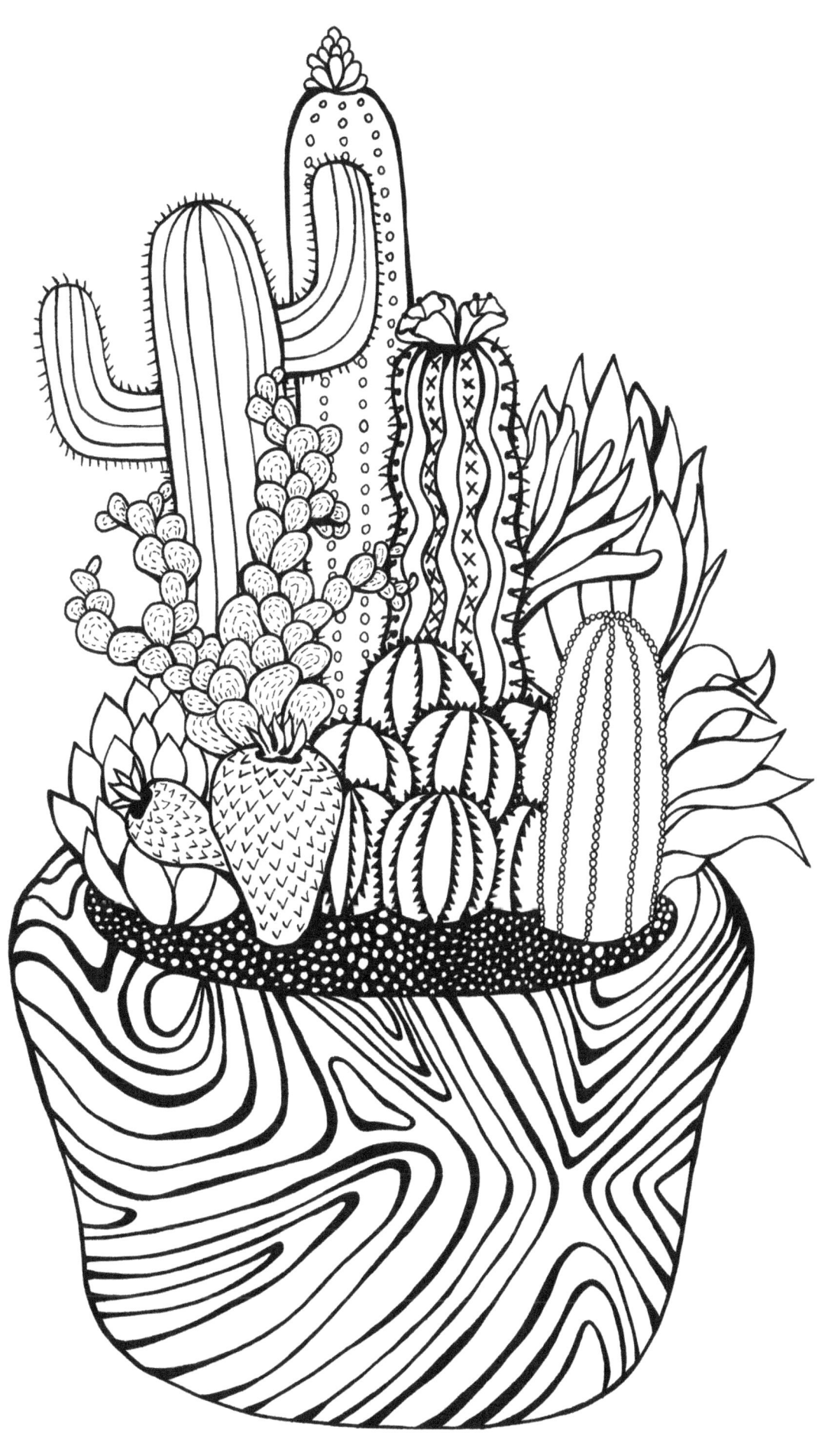

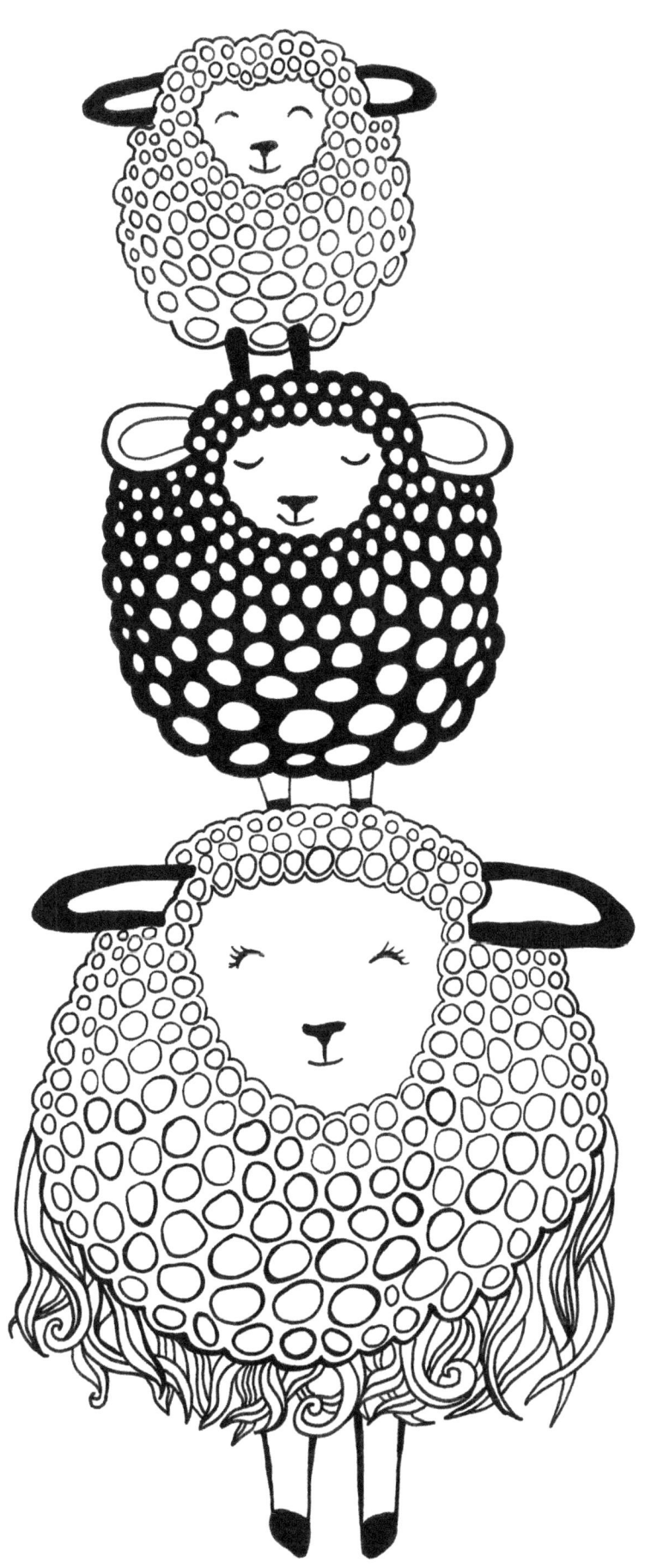

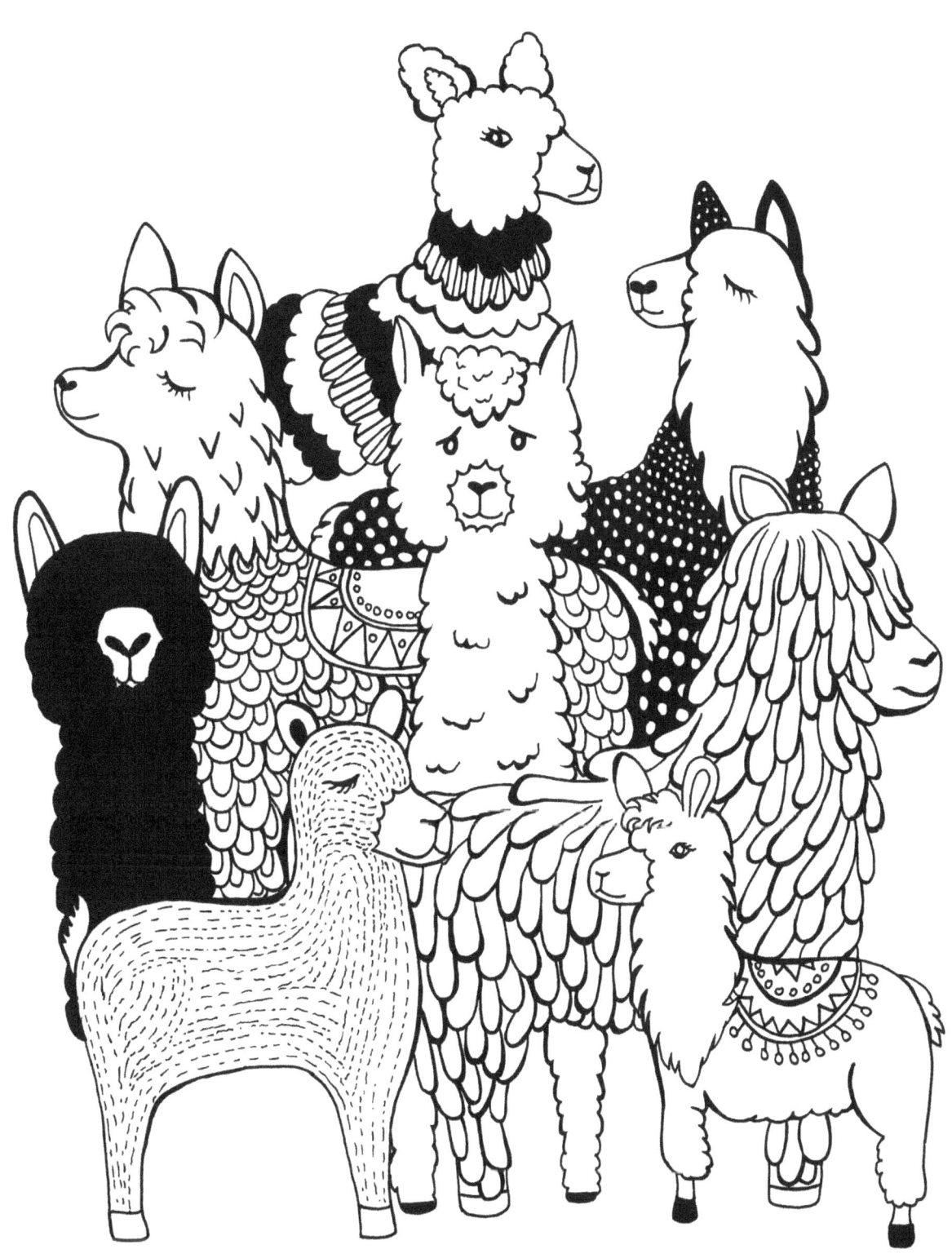

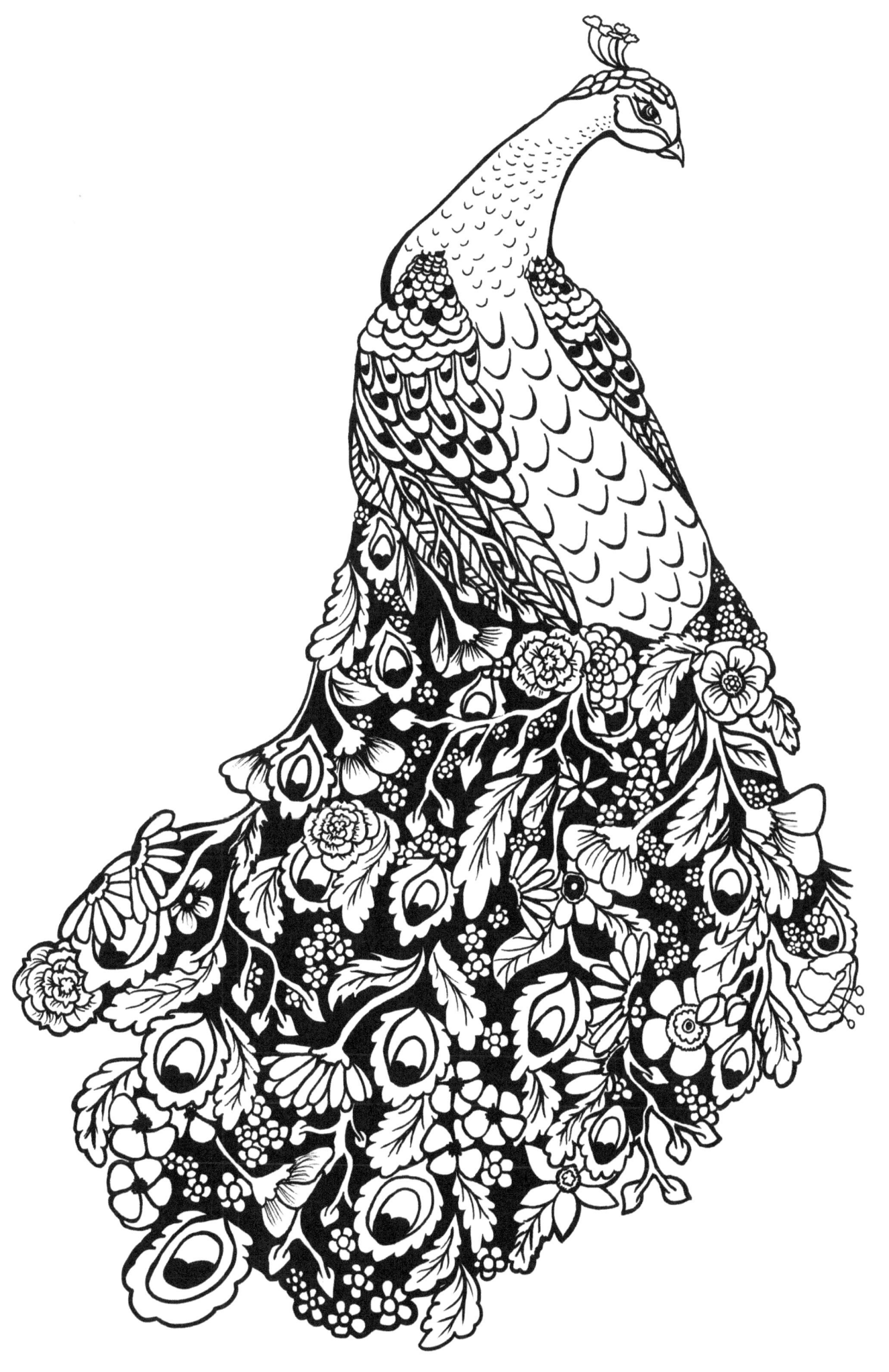

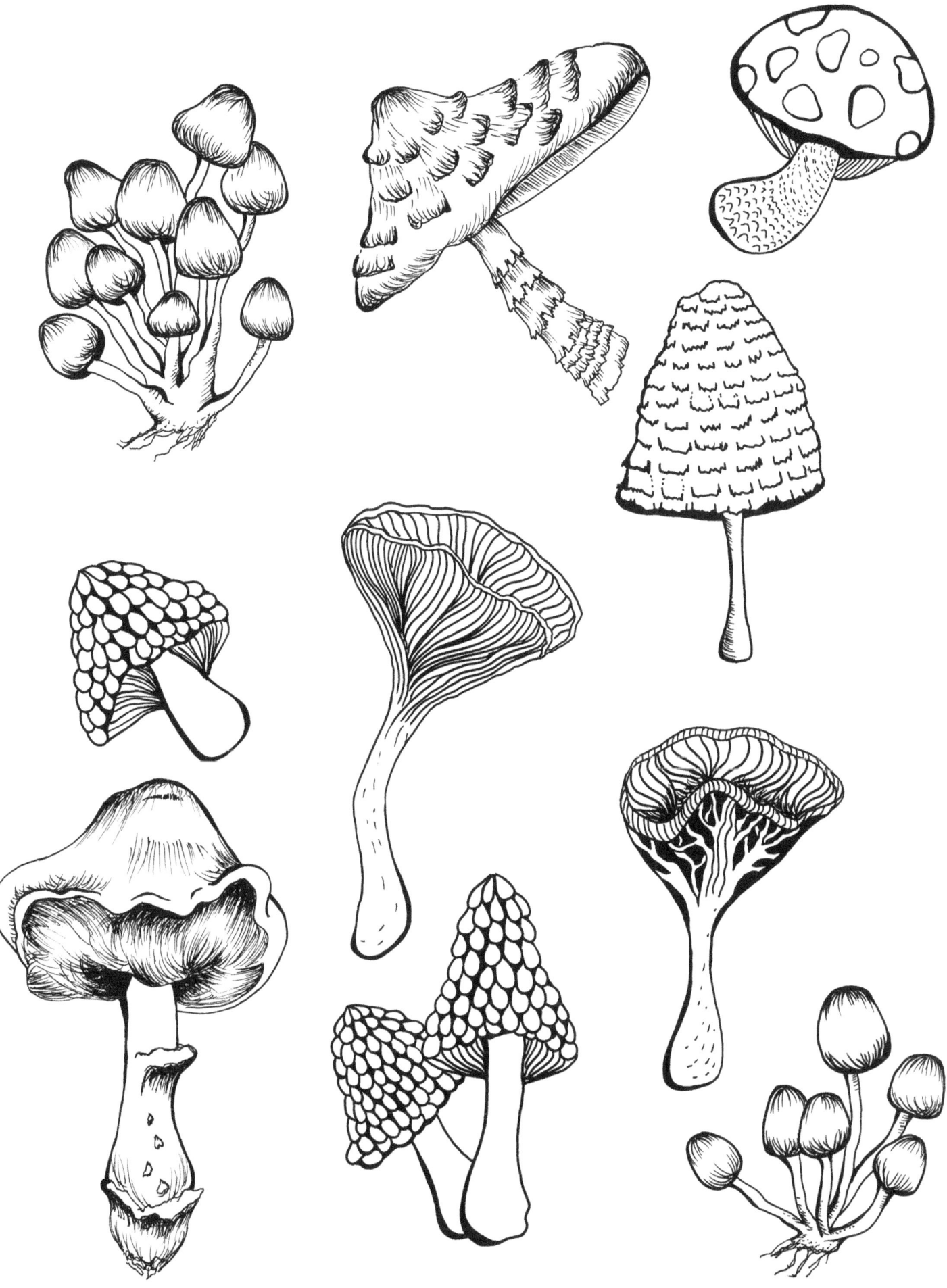

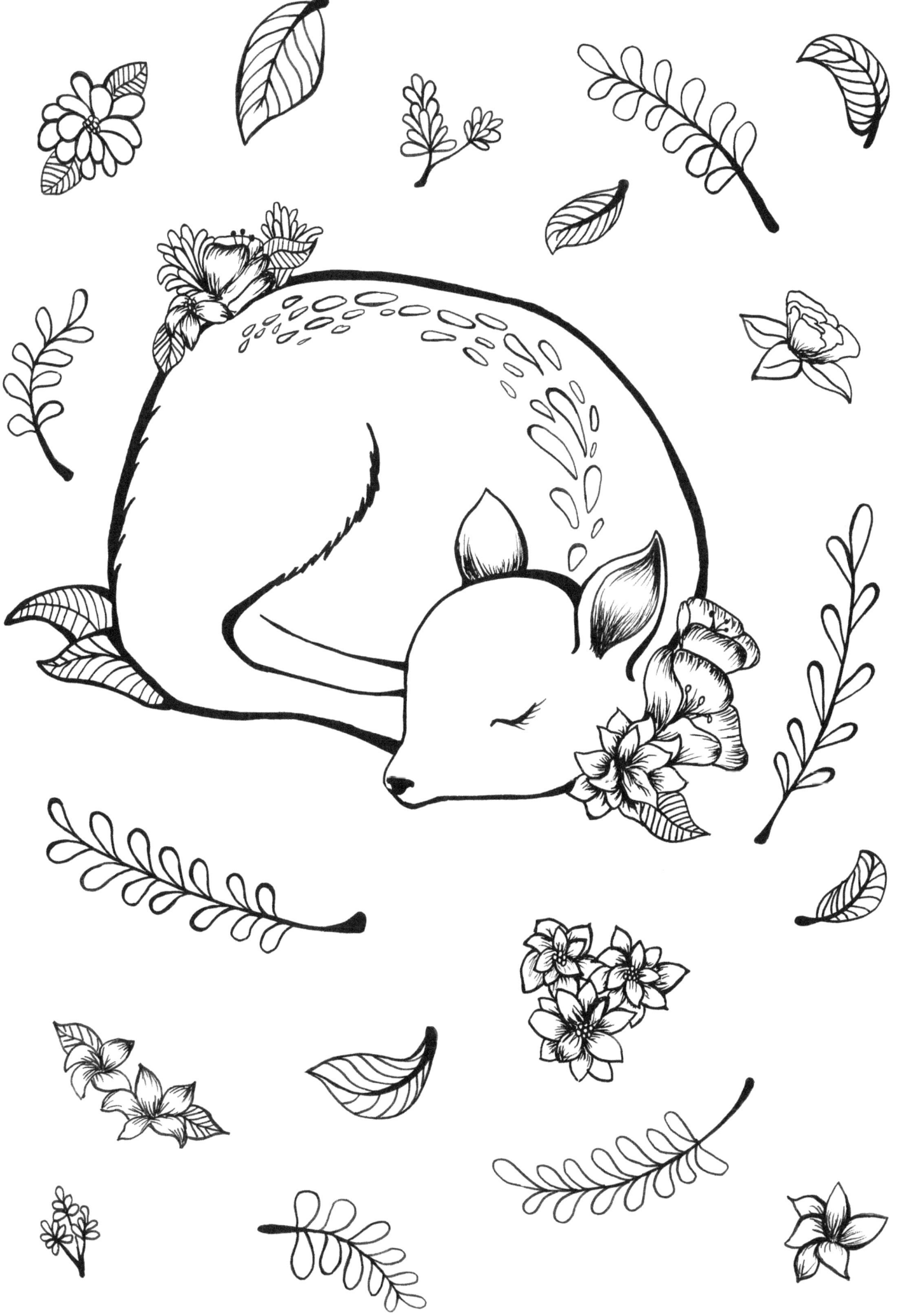

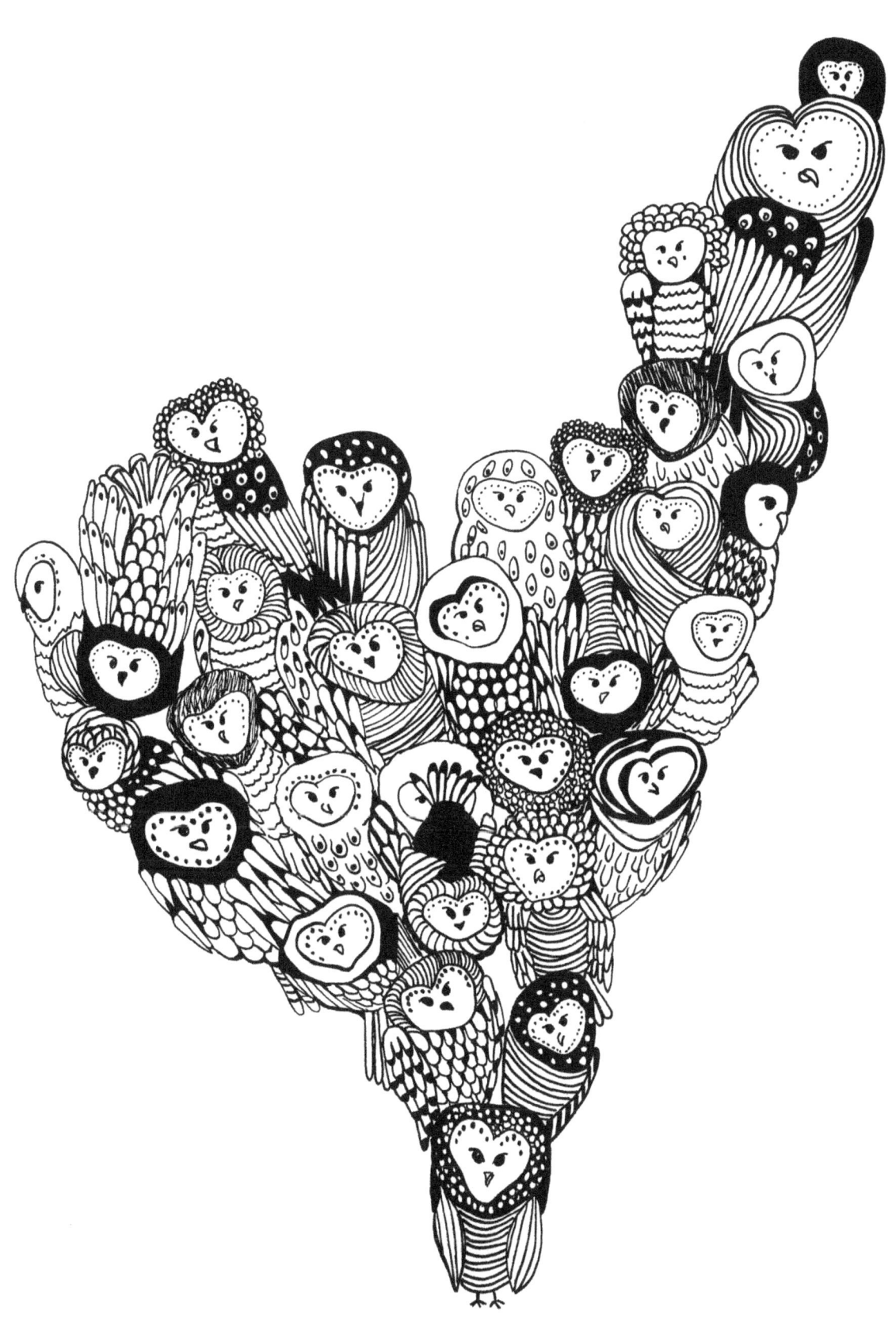

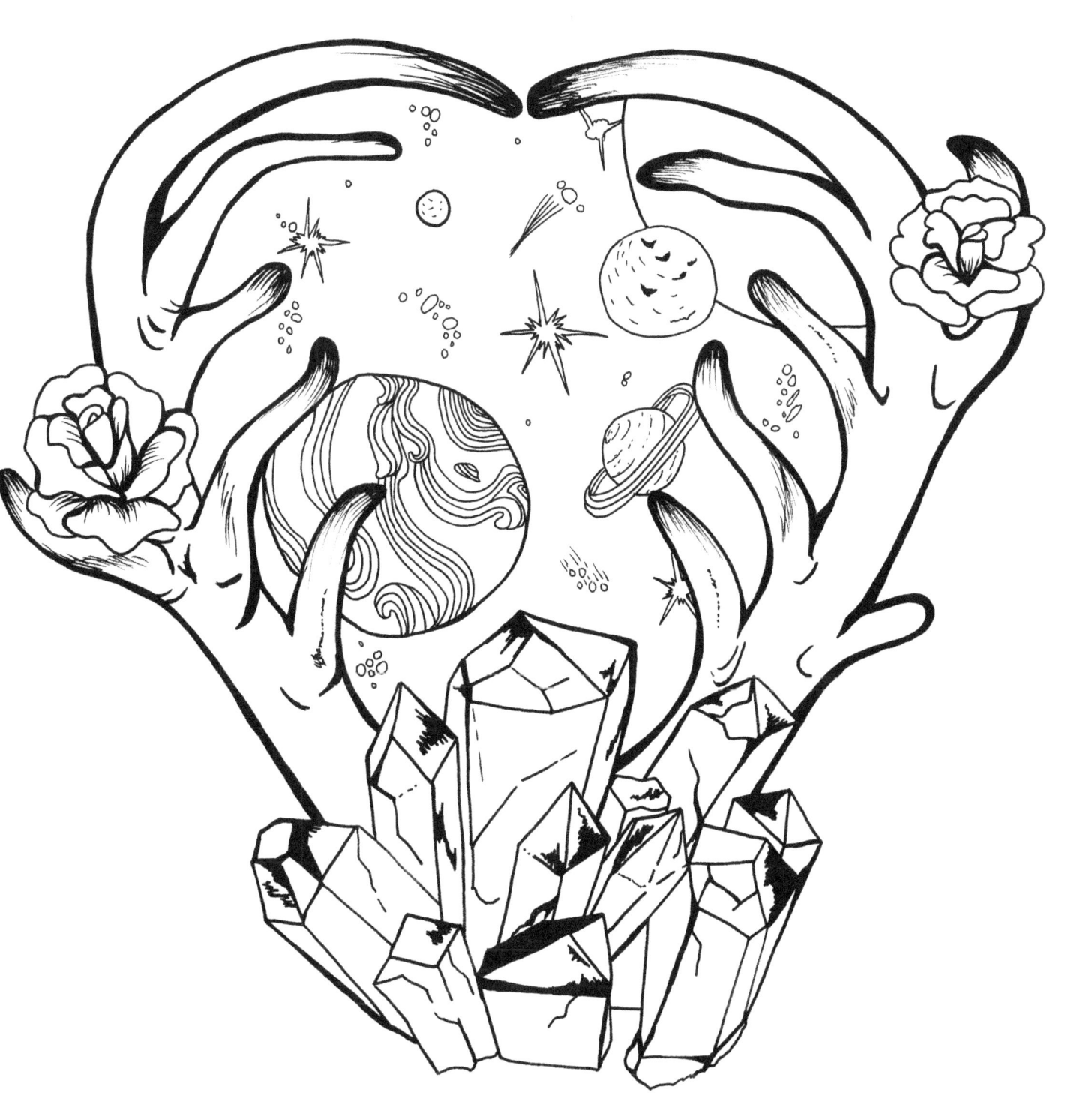

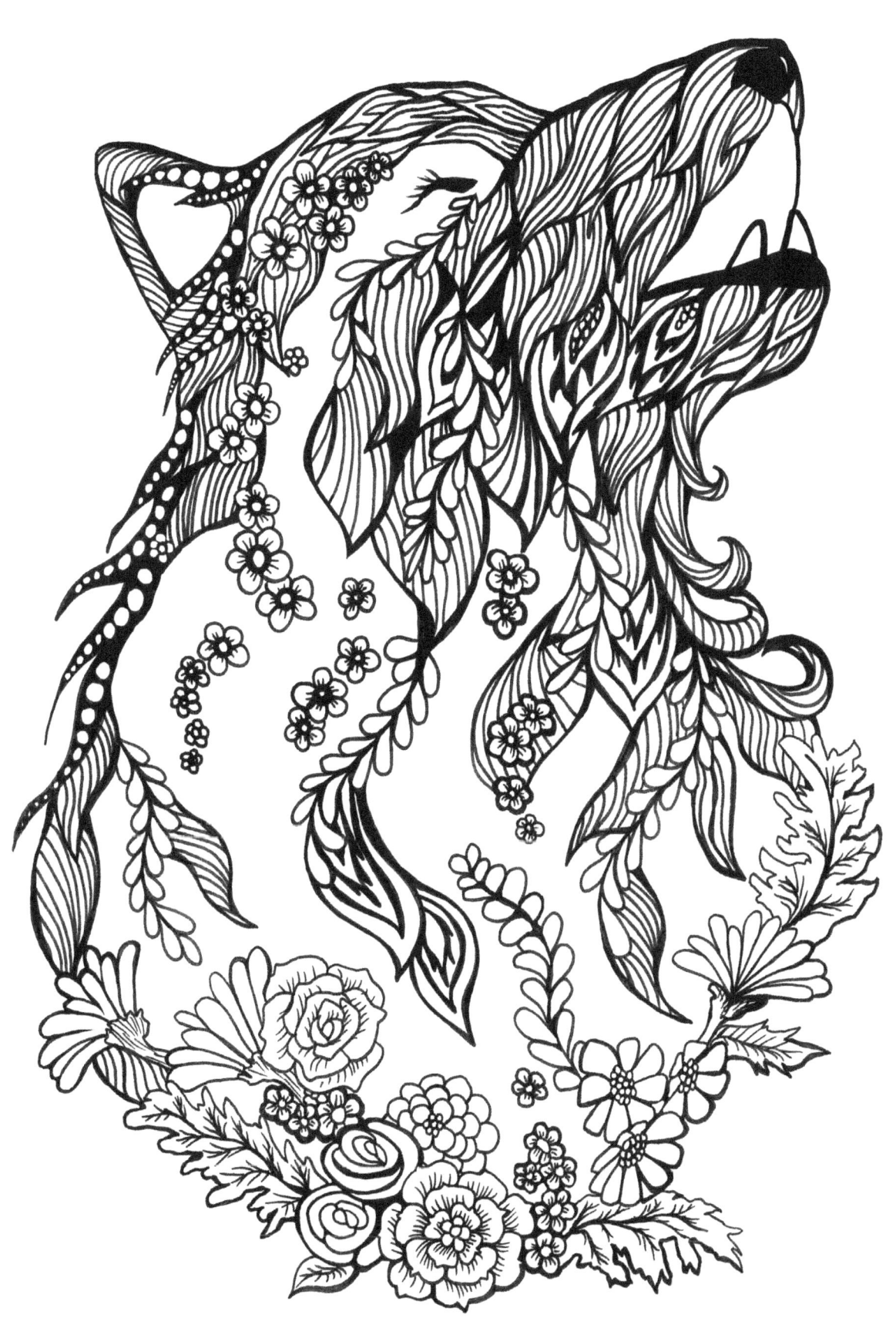

Thank you for your support. You make it possible for me to pursue my dream as an artist. If you enjoyed this book, please leave a review on Amazon!

Check out more products from Karen Sue at Sunshine-Creative.com

YouTube @KarenSueStudios

Share your work! #KarenSueStudios on social media.

www.ingramcontent.com/pod-product-compliance
Lightning Source LLC
Chambersburg PA
CBHW080626190526
45169CB00009B/3298